ornamental design

a source book
with 1000 illustrations
chosen and introduced by
Claude Humbert

A Studio Book • THE VIKING PRESS • New York

Author's note

The research and the collection of examples were
carried out by Sylvia Humbert, to whom I dedicate
this book. The drawings were done by Geneviève
Durand, to whom my thanks go for her collaboration.

Claude Humbert

Published in 1970 by The Viking Press, Inc.
625 Madison Avenue, New York, N.Y. 10022

Published simultaneously in Canada by
The Macmillan Company of Canada Limited

SBN 670-52877-3

Library of Congress catalog card number: 78-101785

Printed and bound in Switzerland

Contents

Introduction

Ce livre est conçu comme un manuel pratique, essentiellement visuel, destiné à tous ceux dont l'activité nécessite l'utilisation de motifs ornementaux. Nous nous sommes limités au choix de mille motifs, sélectionnés parmi plus de cinq mille relevés effectués dans les bibliothèques et musées d'Europe et d'Orient, au cours de voyages. Ce choix a été réalisé essentiellement sur la base de l'évolution graphique.

Les documents étant de sources et de techniques souvent très disparates, nous nous sommes efforcés (sans en altérer l'esprit) de les ramener à un dénominateur graphique commun, pour que leur conception réponde à une utilisation moderne. Une brève étude sur le graphisme ornemental permettra une lecture et une interprétation plus étendue des mille motifs présentés.

Le plan de cet ouvrage est fondé sur la structure des motifs ou la forme de la surface qu'ils décorent: carré, cercle, triangle, motifs continus, végétaux, animaux.

Un index, en fin de volume, donne les références des motifs ornementaux classés par pays, civilisations et époques, permettant ainsi une recherche pratique et rapide.

Nous souhaitons que cet ouvrage constitue un instrument de travail. Il remplirait ainsi le but que nous nous sommes fixé.

Introduction

This book is intended as a practical handbook for everyone whose work involves the use of ornament. A thousand examples have been selected from a total of more than five thousand, collected in the course of my researches in libraries and museums all over Europe and in Asia. My selection has been made primarily in order to illustrate the evolution of graphic signs.

My originals vary widely in origin and in technique; I have therefore tried to bring them to a common denominator in terms of line, without at the same time falsifying their spirit. The short essay which precedes the illustrations is intended to make it easier to read and interpret the thousand designs which I have reproduced.

The designs in this book are arranged according to the various primary forms on which they are based: square, circle, triangle, continuous linear forms, vegetable forms, animal forms.

An index at the end of the book classifies them according to origin and date, for easy cross-reference.

I hope that this book will serve as a working tool; if so, my purpose in compiling it will have been fulfilled.

Einführung

Dieses Buch wurde für den praktischen Gebrauch geschaffen und ist mit seinen vielen Abbildungen für alle bestimmt, die sich in irgendeiner Weise mit der Anwendung von Ornament-Motiven befassen. Von über 5000 Motiven, die wir auf unseren Reisen in den Museen Europas und des Orients zusammengetragen haben, zeigt es nur etwa 1000, die unter dem Gesichtspunkt der graphischen Entwicklung ausgewählt wurden.

Da die Originale in ihrer Herkunft so verschieden waren wie in ihrer handwerklichen Ausführung, haben wir uns bemüht, sie unter Wahrung ihres Charakters auf einen gemeinsamen graphischen Nenner zu bringen, um ihre Fülle für eine moderne Anwendung aufzuschliessen. Eine kurze Abhandlung über die graphische Gesetzmässigkeit des Ornaments soll das richtige Lesen und Interpretieren der 1000 dargestellten Motive erleichtern.

Die Einteilung des Werkes richtet sich nach der Struktur der Motive oder der Grundform der verzierten Fläche: viereckig, rund, dreieckig, Reihung, Rhythmisierung, Pflanzen- und Tiermotive.

Ein Verzeichnis am Ende des Buches orientiert über die Herkunft der einzelnen Ornamentmotive nach Kulturen oder Epochen und erlaubt ein einfaches und schnelles Nachschlagen.

Wir hoffen, dass dieses Buch als Gebrauchswerk die Aufgabe erfüllt, die wir uns gestellt haben.

Le motif ornemental

The ornamental design

Das Ornament-Motiv

Aussi loin que l'on puisse remonter dans l'Histoire, on se rend compte que l'homme a en lui le désir impérieux de décorer les objets usuels et le cadre dans lequel il vit. Ses sources d'inspiration sont d'ordre géométrique ou technique et parfois elles reflètent tout simplement le milieu naturel ambiant (fig. 1).

Ce besoin de créer se retrouve à travers toutes les époques et toutes les civilisations. Et si le style des motifs se modifie au cours des âges, leur permanence n'en demeure pas moins et ne cessera jamais d'exister, parce qu'elle fait partie de l'homme. C'est dire à quel point l'étude et la recherche des motifs ornementaux est passionnante. Leur graphisme est une écriture qui permet de définir non seulement le degré de civilisation d'un peuple, mais encore son caractère profond et essentiel. On lit, grâce à l'examen et à la confrontation, toute l'histoire des peuples et l'influence des civilisations les unes sur les autres.

Since the earliest days of man's history, he has manifested the desire to decorate the things he uses and the places where he lives. His sources of inspiration may be geometric or functional, or they may reflect the surrounding natural world (Fig. 1).

This creative desire reappears in every period and in every civilization. And if the style of the ornaments changes in the course of the years, the basic forms themselves remain. They are, in fact – and this is why the evolution of ornamental design is such a fascinating subject – permanent factors of human experience. Their variations make up the distinctive ' handwriting ' of any given society, which reveals not only its degree of civilization but its essential character, while comparative study of ornamental design reveals the evolution and the interaction of civilizations.

So alt wie der Mensch ist auch sein Bemühen, die Gebrauchsgegenstände und seine Behausung zu schmücken. Die Urformen sind sowohl geometrisch als naturalistisch bestimmt (Fig. 1).

Diese schöpferische Freude findet sich in allen Epochen und Kulturen. Mit dem Wandel der Stilformen entstehen auch neue Ornamente, deren Motive stets ein Stück menschlicher Ausdruckssprache sind. Gerade das lässt das Studium von Ornament-Motiven so faszinierend erscheinen. Sie sind eine graphische Schriftform, die nicht nur den Kulturgrad eines Volkes, sondern auch seinen Charakter und sein Wesen bestimmen hilft. Durch Prüfung und Gegenüberstellung von Ornamenten enthüllt sich die Geschichte der Völker und ihre Beeinflussung durch andere Kulturen.

1

1: Graphisme influencé par le milieu naturel ambiant. Préhistoire, San Juan, Nouveau-Mexique, U.S.A.

1: *Design influenced by natural form. Prehistoric, San Juan, New Mexico, U.S.A.*

1: Die Graphik ist von der umgebenden Natur beeinflusst. Prähistorisch. San Juan, Neu-Mexiko, U.S.A.

Le motif ornemental se distingue par sa structure et sa forme, et par le rythme que crée sa répétition. A leur origine les motifs sont simples et non figuratifs. C'est essentiellement le rythme qui leur confère un caractère ornemental (fig. 2 et 3).

Dans certaines civilisations, le motif ornemental est né du symbole religieux. Très simple et direct au départ, il suivra une évolution qui l'amènera à ne conserver de son origine que la structure de base. Nous donnons ci-dessous l'exemple du soleil sumérien, chaldéen et hittite qui, parti d'un symbole rudimentaire au point de vue graphique, deviendra par évolution une représentation décorative (fig. 4).

Ornamental motifs are distinguished by colour and shape, and by the rhythms which they set up when they are repeated. At their origin, forms are simple and non-figurative. They achieve an ornamental effect basically through repetition (Figs 2 and 3).

In certain civilizations, the ornamental motif is a product of a religious symbol. Initially simple and direct, it undergoes an evolution which leaves intact only its basic structure. Shown here is the solar symbol of the Sumerians, Chaldeans and Hittites, which progressed from rudimentary symbol to decorative pattern (Fig. 4).

Ornament-Motive unterscheiden sich durch die Struktur, die Form und durch den Rhythmus ihrer Wiederholungen. Ursprünglich sind die Motive einfach und nicht figürlich; ihren Charakter als Ornament gibt ihnen der Rhythmus (Fig. 2 und 3).

In manchen Kulturen hat das Ornament-Motiv seinen Ursprung im religiösen Symbol. Von der schlichten geradlinigen Urform nimmt es eine Entwicklung, die zuletzt kaum noch die Grundstruktur erkennen lässt. Wir geben dazu das nachfolgende Beispiel der sumerischen, chaldäischen und hethitischen Sonne, die — graphisch gesehen ein Ursymbol — sich zu einer dekorativen Form entwickelt (Fig. 4).

2: Le motif ornemental est fonction du rythme créé par la répétition irrégulière d'un élément géométrique simple. Art mycénien, 2me millénaire av. J.-C., Tirynthe, Grèce.
3: Ornement où domine la liberté d'expression. Le style est défini par la convergence dynamique des motifs répétés. Age de la pierre, Chine.

2: The ornamental motif is the product of the rhythm set up by the irregular repetition of a simple geometrical form. Mycenean, Tiryns, Greece, 2nd millennium BC.
3: Ornament based on free expression. The style is defined by the dynamic convergence of the repeated forms. China, Stone Age.

2: Das Ornament-Motiv zeigt den Rhythmus einer unregelmässig wiederholten, geometrischen Grundform. Mykenisch, 2. Jahrtausend v. Chr. Tiryns, Griechenland.
3: Ornament mit grosser Freiheit im Ausdruck. Der Stil wird von der dynamischen Konvergenz sich wiederholender Motive bestimmt. Chinesisch, Steinzeit.

2

3

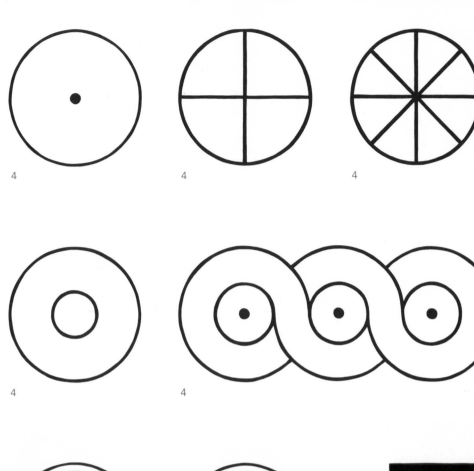

4: Evolution schématique du graphisme symbolisant le Dieu Soleil dans les civilisations sumérienne, chaldéenne et hittite.
5, 6: Croix gammées: svastika (fig. 5) et sauvastika (fig. 6). Motif ornemental symbolique. La figure 6 est le relevé d'un bijou or préhittite, 3me millénaire av. J.-C.

4: Schematic representation of the development of the symbol representing the sun god in the Sumerian, Chaldean and Hittite civilizations.
5, 6: Solar crosses: the swastika (fig. 5) and the sauvastika (fig. 6). A symbolic motif. Fig. 6 is taken from a pre-Hittite gold ornament, Asia Minor, 3rd millenium B.C.

4: Schematische Entwicklung des symbolischen Sonnen-Zeichens in der sumerischen, chaldäischen und hethitischen Kultur.
5, 6: Hakenkreuz: Swastika (Fig. 5) und Sauvastika (Fig. 6). Symbolisches Ornament-Motiv. Figur 6 ist die Skizze eines prä-hethitischen Goldschmucks. 3. Jahrtausend v. Chr.

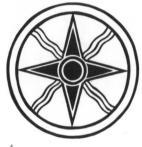
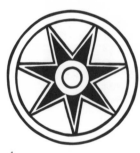

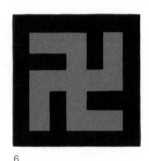

4 4 5 6

On peut citer également les fameuses svastikas et sauvastikas (croix gammée et son image renversée, fig. 5 et 6) que l'on retrouve dans de nombreuses civilisations, notamment au Moyen-Orient et en Orient. Les variations sur leur structure de base sont innombrables (cf. pages 39, 40, 42, 43).

Another example is the swastika, or sun wheel, in its left-handed and right-handed forms (Figs 5 and 6), which reappears in numerous Middle and Far Eastern civilizations. The possible variations on this simple basic structure are innumerable (see pp. 39, 40, 42, 43).

Hierher gehören auch die berühmten Swastika und Sauvastika (Hakenkreuz, Fig. 5 und 6), die man in zahlreichen Kulturen vor allem des mittleren und fernen Orients wiederfindet. Es gibt unzählige Abwandlungen ihrer Grundstruktur (Seiten 39, 40, 42, 43).

On a le sentiment que les créateurs, à partir d'un élément géométrique très simple, se sont amusés à déployer une imagination sans limite sur le plan ornemental, tout en respectant certaines lois de composition valables encore aujourd'hui, qui s'appuyent sur des sentiments instinctifs immuables. Ces lois, pour la plupart, sont devenues des conventions de l'inconscient. Les fig. 7, 8 et 9 par exemple, auront toujours et pour chacun la même signification: calme, repos: ligne morte (fig. 7); élévation, aspiration au supérieur: ligne verticale (fig. 8); mouvement, dynamisme, action: ligne oblique (fig. 9). De même les compositions angulaires révèlent une grande rigueur et une domination de l'esprit alors que les compositions en arrondis font appel au sentiment. Elles peuvent aller jusqu'à suggérer une molle décadence.

One feels that ancient artists, setting out from a very simple geometrical element, took pleasure in giving full rein to their imagination, while respecting a number of compositional rules which are still valid today. These laws have become, in most cases, conventions of the unconscious. Simple horizontal, vertical and oblique lines, for example, possess a universally valid significance: calm and repose (Fig. 7), uplift and aspiration (Fig. 8), movement and energy (Fig. 9). Similarly, angular forms reveal severity, the dominance of the intellect, while curved forms make an appeal to the emotions, and may even suggest decadence and submission.

Man hat den Eindruck, dass schon einfache Grundelemente die grenzenlose Erfindungsgabe beflügelten. Dabei beachteten die frühen Künstler stets gewisse Kompositionsgesetze, die, weil sie einem unveränderlichen Gestaltungswillen entsprechen, auch heute noch gültig sind. Sie sind zum grossen Teil unbewusste Konventionen geworden. Die Fig. 7, 8 u. 9 beispielsweise werden für immer und für jedermann die gleiche Bedeutung haben: Gelassenheit und Stille = horizontale Linie (Fig. 7); Erhebung, Streben nach Höherem = senkrechte Linie (Fig. 8); Bewegung, Dynamik, Schwung = schräge Linie (Fig. 9). Ebenso stehen eckige Kompositionen für geistige Strenge, während die gerundeten sich an das Gefühl wenden. Sie können sogar den Eindruck einer gewissen Dekadenz erwecken.

7, 8, 9: Lignes essentielles de construction sur lesquelles viennent se structurer les manifestations d'imagination les plus variées.

7, 8, 9: The basic linear constructional elements which underlie all symbolic and ornamental invention.

7, 8, 9: Hauptlinien einer Konstruktion, aus denen sich die verschiedenartigsten Phantasiegebilde entwickeln.

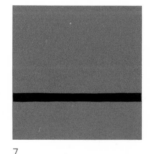

7

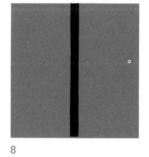

8

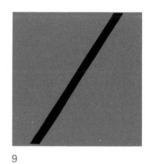

9

On peut ajouter, concernant la perception psychologique des motifs ornementaux, le sens symbolique que certaines civilisations leur ont conféré. Le symbole complète le graphisme en lui donnant une signification, au même titre que les mots donnent un sens à l'écriture (fig. 10 et 11). C'est un sujet trop vaste pour que nous nous aventurions à le traiter ici; à lui seul il pourrait faire l'objet d'une longue étude.

A further aspect of the psychological significance of certain ornamental motifs is the symbolic use to which certain civilizations have put them. The symbol completes the graphic sign by endowing it with a significance, just as verbal content completes the written sign (Figs 10 and 11); but this immense subject demands a long book to itself.

Bei der psychologischen Deutung der Ornament-Motive sei auch an den Symbolwert erinnert, der für frühe Kulturen damit verbunden war. Die graphische Versinnbildlichung des Symbols gibt erst dem Ornament jenen Sinngehalt, den das Wort inmitten von Schriftzeichen hat (Fig. 10 u. 11). Doch ist dieses Thema zu komplex, um hier behandelt zu werden; es müsste selbst wiederum Gegenstand einer ausführlichen Studie sein.

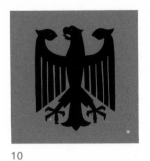

10

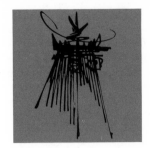

11

13

12

13

10 : Aigle de la République fédérale d'Alle-magne. Type du symbole graphique dans l'héraldique : domination et puissance.
11 : Aigle dessiné par le peintre Georges Mathieu pour une affiche de la compagnie Air France. L'artiste le définit ainsi : «Il a le romantisme de Novalis, l'autorité de Frédéric le Grand, la majesté d'une symphonie de Beethoven, la nostalgie du gothique, l'uni-versalité de Goethe.»
12 : Motif ornemental en continu. Forme inté-rieure normalement perçue par notre vision.
13 : Forme extérieure du même motif, compa-rable à la coquille d'une noix ou à un moule.

10 : *The eagle emblem of the Federal Republic of Germany. A typical heraldic symbol, rep-resenting dominance and power.*
11 : *Eagle designed by the painter Georges Mathieu for an Air France poster. The artist defines it as follows: 'It has the romanticism of Novalis, the authority of Frederick the Great, the majesty of a Beethoven symphony, the nostalgia of Gothic, the universality of Goethe.'*
12 : *Section of a continuous pattern: the inner (enclosed) form, as normally perceived.*
13 : *Outer form of the same design, acting as a shell or mould.*

10 : Adler der Bundesrepublik Deutschland. Gra-phisches Symbol der Heraldik : Herrschaft und Macht.
11 : Adler, von dem Maler Georges Mathieu für das Deutschland-Plakat der Fluggesellschaft AIR FRANCE. Der Künstler erklärt : «Er hat die Romantik von Novalis, die Autorität Friedrichs des Grossen, das Majestätische einer Beethoven-Symphonie, das Sehnsüch-tige der Gotik, die Weltweite Goethes».
12 : Fortlaufendes Ornament-Motiv (Australien). Die Innen-Form, wie sie sich gewöhnlich unserem Auge bietet.
13 : Die Aussen-Form des gleichen Motivs, einer Nusschale oder Muschel vergleichbar.

Le motif ornemental, tel qu'il a été traité dans ce volume, est une forme graphique que nous percevons par la vue. Ce graphisme est un tout que nous lisons par sa forme intérieure, comparable à une silhouette. Dans la fig. 12, nous comprenons le motif tracé en noir, les surfaces blanches nous apparaissant comme un arrière-plan. C'est donc bien le noir qui définit le graphisme de la forme que nous enregistrons dans son ensemble, et d'un seul coup d'œil, par l'intérieur. La fig. 13, au contraire, nous livre de façon immédiate la forme extérieure. Elle est d'un graphisme très différent de la première, le tracé étant pourtant rigoureusement semblable. Lorsque la forme intérieure est équivalente à la forme extérieure, le sens dans lequel est tourné le motif définit également la perception (fig. 14 et 15).

The ornamental motif, as it is considered in this book, is a graphic entity which we 'read' by tracing the outline of the space enclosed within it. We perceive Fig. 12 as a black shape against a white background; the black area in the design serves to define, from within, the outline of the form, which we recognize at a single glance. In Fig. 13, on the other hand, what we perceive at first glance is the outer form, the background. The whole is very different in effect from Fig. 12, although the outline of the central form is exactly the same. When the enclosed form duplicates the outer (background) form, the way in which the motif is perceived changes when the motif is inverted (Figs 14 and 15).

Das Ornament-Motiv, wie es in diesem Band behandelt wurde, ist graphische Form und als solche eine Einheit, die sich aus ihren Umrissen wie eine Silhouette erschliesst. In Fig. 12 erfassen wir das schwarz gezeichnete Motiv, die weissen Flächen erscheinen als Hintergrund. Das Schwarz bestimmt das Ganze, dessen Graphik sich uns mit einem einzigen Blick auf die Innenform erschliesst. Die Fig. 13 dagegen spricht durch die äussere Form. Hier ist die graphische Wirkung von der ersten sehr verschieden, obwohl die Linienführung genau vergleichbar ist. Sind innere und äussere Form gleichwertig, so bestimmt die Richtung, in die das Motiv gedreht wird, auch gleichermassen die Wirkung auf den Betrachter (Fig. 14 u. 15).

14, 15: Lecture du motif ornemental en blanc ou en noir, suivant le sens dans lequel il est tourné. Encadrement en mosaique, époque des Ptolémées, Pergame, Asie Mineure.

14, 15: Form perceived as black on white, and as white on black, according to orientation. Mosaic border, Ptolemaic period, Pergamum, Asia Minor.

14, 15: Auslegung des Motivs in Schwarz oder Weiss, je nach der Richtung, in der es gehalten wird. Mosaik-Umrahmung, Ptolemäischer Stil, Pergamon, Kleinasien.

14

15

La lecture des motifs ornementaux est un facteur important non seulement pour leur compréhension, mais également pour leur utilisation. Un examen attentif permet de découvrir parfois un nombre de graphismes insoupçonné et d'un aspect inattendu. Ceci est valable notamment pour les tracés de base qui permettent, suivant la loi des contrastes, de nombreuses interprétations. La fig. 16 donnant la structure sur un principe de croix gammée, les fig. 17 et 18 font la démonstration d'une vision chaque fois renouvelée. Les exemples les plus frappants de ce phénomène de transformation visuelle se trouvent dans les tracés arabes. Il est courant de lire à partir d'une structure de base jusqu'à quatre interprétations du motif, y compris le volume qui fait éclater la troisième dimension (fig. 19, 20, 21, 22, 23).

The way in which ornamental motifs are 'read' is an important factor not only in their comprehension but also in their use. A careful examination sometimes reveals new and unsuspected forms within a given design. Fig. 16 establishes a basic structure founded on a swastika; Figs 17 and 18 illustrate its possibilities of renewal. The most striking examples of this phenomenon of visual metamorphosis can be found in Arab ornamental forms. One basic structure often gives rise to as many as four interpretations of the motif, including one which involves a spatial effect (Figs 19–23).

Das richtige Lesen der Ornament-Motive ist nicht nur für ihr Verständnis, sondern auch für ihre Anwendung äusserst wichtig. Bei aufmerksamer Prüfung stossen wir daher manchmal auf völlig unerwartete graphische Aspekte. Das gilt vor allem für die Grundformen, die nach dem Gesetz der Kontrastwirkung vielerlei Auslegungen zulassen. Während die Struktur von Fig. 16 auf der Grundform des Hakenkreuzes beruht, zeigen die Fig. 17 und 18 jedesmal einen neuen Aspekt. Die verblüffendsten Beispiele für dieses Phänomen der optischen Verwandlung finden sich in arabischen Zeichnungen. Für gewöhnlich lassen sich aus einer Grundstruktur bis zu vier Motiv-Auslegungen herauslesen (Fig. 19, 20, 21, 22, u. 23).

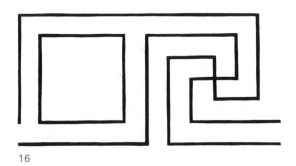

16

16: Bande continue en mosaïque, époque des Ptolémées, Délos, Grèce.
17, 18: Deux interprétations du motif de base. La croix gammée n'est même plus apparente, quoiqu'elle en demeure la structure.

16: Linear motif from a mosaic. Delos, Ptolemaic period.
17, 18: Two interpretations of the motif in Fig. 16; although present, it is no longer apparent.

16: Fortlaufendes Mosaik-Band. Ptolemäerzeit, Delos, Griechenland.
17, 18: Zwei Auslegungen des Grundmotivs. Das Hakenkreuz ist nicht mehr sichtbar, obwohl es als Struktur bleibt.

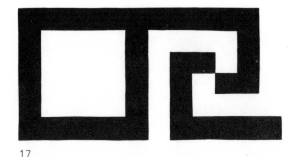

17

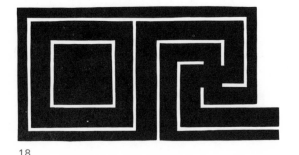

18

19: Tracé arabe définissant une structure sur la base de laquelle la réalisation peut s'effectuer en divers matériaux. On dénombre plusieurs centaines de variations de tracés, faisant tous preuve d'une imagination sans précédent dans le motif ornemental géométrique.
20, 21, 22, 23: Quatre possibilités d'interprétation visuelle du motif tracé en figure 19.

19: One of the basic structures in Arab ornamental design. These appear in hundreds of different interpretations—an imaginative achievement unique in the history of ornamental design.
20, 21, 22, 23: Four possible interpretations of the outline in Fig. 19.

19: Arabisches Muster. Eine Struktur, die sich in verschiedenem Material ausführen lässt. Es gibt hundertfach abgewandelte Muster, die von einer unglaublichen Erfindungsgabe auf dem Gebiet des geometrischen Ornaments zeugen.
20, 21, 22, 23: Vier Auslegungsmöglichkeiten des Motivs von Fig. 19.

19

20

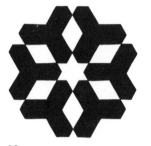
21

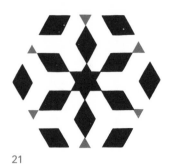

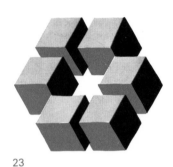
22 23

Dans l'ensemble, les motifs ornementaux suggérant le volume sont en minorité évidente. Les moyens mis en œuvre pour permettre cette suggestion d'une troisième dimension sont très variables. Nous en donnerons trois exemples caractéristiques. Le plus usuel et le plus simple est celui de l'introduction d'une ombre à 45 degrés comme le montre la fig. 24, où le volume apparaît d'une façon très démonstrative. Le principe d'ombre peut être renforcé par la forme et le rythme du motif ornemental. Des chevrons en continu par exemple, avec adjonction d'une ombre, créent visuellement des plans obliques, comparables à l'arête d'un toit à deux pans (fig. 25). Le troisième exemple enfin, suggère le tissage ou le tressage dont il est issu (fig. 26 et 27). Par analogie, la perception en est instinctive. Nous ne faisons aucun effort pour suivre les éléments et les voir passer les uns sur les autres, alors que, graphiquement, ils sont simplement juxtaposés.

Only a minority of ornamental motifs incorporate a suggestion of volume. They do so in a number of widely differing ways, of which I shall instance three. The most common, and the simplest, consists in the introduction of a shadow at an angle of 45 degrees; Fig. 24 shows this clearly. Secondly, the effect of shadow may be reinforced by the form and the rhythm of the design itself. Linked chevrons, for example, with an added shadow, create the visual impression of inclined planes like those of a pitched roof (Fig. 25). Finally, the ornament may suggest weaving or plaiting (Figs 26 and 27). The effect is perceived instinctively, by analogy: no effort is required to follow the forms and to see them as passing over and under each other, even though, in graphic terms, they are merely juxtaposed.

Im ganzen sind die Ornament-Motive mit räumlicher Wirkung selten, und die Mittel, die Vorstellung dieser dritten Dimension hervorzurufen, sind verschiedenartig. Wir geben dafür drei charakteristische Beispiele. Am gebräuchlichsten und einfachsten ist es, mit einem Schlagschatten von 45° zu arbeiten, wodurch, wie Fig. 24 zeigt, das Räumliche in sehr überzeugender Weise in Erscheinung tritt. Die Wirkung des Schattens kann durch die Form und den Rhythmus des Ornament-Motivs verstärkt werden. Fortlaufende Zickzackflächen zum Beispiel, die schattenähnliche Wirkung erreichen, lassen optisch schräge Ebenen, ähnlich einem First mit zwei Dachflächen, entstehen (Fig. 25). Das dritte Beispiel zeigt ein von Flechtwerk abgeleitetes Gewebe (Fig. 26 u. 27). Mit dem realen Vorbild erfasst man instinktiv beide. Es ist leicht, die Verwandtschaft der einzelnen Elemente zu erkennen.

24

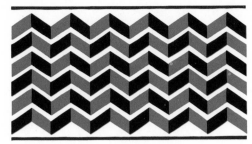

25

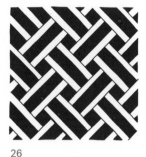

26

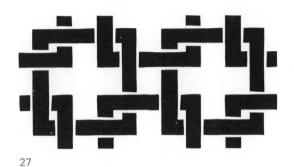

27

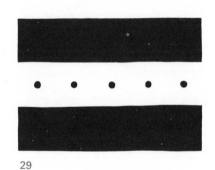

28

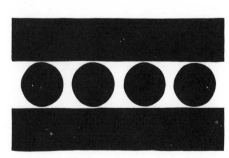

29

30

31

24: Motif ornemental en continu. Quoiqu'en deux dimensions, suggestion du volume par l'ombre à 45°. Chine.

25: La troisième dimension est suggérée par le rythme en chevrons. Motif ornemental du Congo.

26: Motif ornemental issu du tissage. Le graphisme suggère les différents plans. Bakubas, Congo.

27: Ornement en continu. Le volume est simplement suggéré par le passage des différents éléments les uns sur les autres. Japon.

28, 29, 30, 31: Sur un principe de répétition d'éléments semblables, la modification des surfaces change l'aspect du motif ornemental dans son ensemble.

24: *Section of continuous pattern. Relief is suggested by the 45-degree shadow. China.*

25: *Volume suggested by the use of chevrons. Congo.*

26: *Ornament derived from weaving. The outlines suggest the presence of more than one plane. Bakuba tribe, Congo.*

27: *Section of continuous pattern. Relief is suggested by the way in which one form passes over another. Japan.*

28, 29, 30, 31: *Repeated patterns using identical shapes; the relationships of size govern the overall visual effect.*

24: Fortlaufendes Ornament-Motiv. Obwohl zweidimensional, wird durch den Schatten von 45 Grad der Eindruck des Räumlichen hervorgerufen. China.

25: Die dritte Dimension wird durch den Rhythmus der Sparren angedeutet und durch den Schatten betont. Ornament-Motiv aus dem Kongo.

26: Gewebe. Die Graphik deutet die verschiedenen Ebenen an. Ornament der Bakuba, Kongo.

27: Fortlaufendes Ornament. Hier wird der Raum nur dadurch angedeutet, dass die verschiedenen Teile übereinander laufen. Japan.

28, 29, 30, 31: Nach dem Grundsatz der Wiederholung ähnlicher Elemente verändert die Abwandlung der Oberflächen das Aussehen des ganzen Ornament-Motivs.

Les proportions jouent un rôle important dans le motif ornemental. D'une part les proportions du motif lui-même, qui en définissent le caractère ou le style, et d'autre part les proportions choisies pour sa répétition. La fig. 28 présente le thème ornemental: une série de cercles se répétant régulièrement et horizontalement, encadrés de deux filets. Le motif est nettement en minorité par rapport à la surface définie. Les fig. 29, 30 et 31 inversent le rapport d'occupation de la surface, et couvrent progressivement tout l'espace par l'ornement. Ceci pour montrer simplement qu'à partir d'un même principe et avec des éléments semblables, on peut modifier complètement l'aspect d'un motif ornemental sur le plan de sa perception visuelle. Le motif peut aussi influencer la lecture de la surface qu'il orne. Si nous regardons les fig. 32 et 33 nous avons le sentiment que les rectangles, ornés d'une bande encadrée de filets, ne sont pas semblables. Celui de la fig. 33 nous apparaît plus trapu et plus court, alors que les deux rectangles sont absolument identiques. C'est simplement le sens de l'ornement qui, l'emportant visuellement sur la surface, prend toute sa signification (cf. fig. 7 et 8).

Il faut noter que les mille motifs ornementaux qui suivent sont tous présentés en deux dimensions; plus du tiers décorant un volume a été ramené à cette vision. Il est du reste intéressant d'étudier la réaction de la forme appliquée à la troisième dimension. Les exemples ci-dessous illustrent clairement la transformation d'un graphisme lorsqu'il est adapté à une forme dans l'espace (fig. 34, 35 et 36).

Proportions play an important part in the composition of ornamental motifs. On the one hand, there are the proportions of the motif itself, which define its character and its style, and on the other there are the proportions of the pattern created by its repetition. Fig. 28 presents the elements of a pattern: a series of circles repeated regularly along a horizontal plane, and flanked by two straight lines. The motif occupies only a small proportion of the surface which it defines. Figs 29–31 reverse the ratio of form to background and progressively fill the available space with ornament. This shows how it is possible, without altering either the shape of the components or their arrangement, to transform the visual effect of a motif completely. The motif may also alter the visual properties of the surface which it decorates. The basic rectangle in Fig. 33 seems shorter and wider than that in Fig. 32, although they are in fact identical. The ornament, in this case a dark band between two lines, is stronger in visual impact than the surface, and distorts the meaning which it conveys (Figs 7 and 8).

The thousand motifs illustrated in this book have all been projected on to a plane surface, although more than a third of them are taken from three-dimensional objects. The examples in Figs 34–36 illustrate the interesting process of modification which a graphic sign undergoes when it is adapted to a spatial form.

Eine besonders wichtige Rolle spielen auch die Proportionen, und zwar sowohl die Proportionen des Motivs selbst, die seinen Charakter oder Stil bestimmen, als auch die für die Wiederholung gewählten Grössenverhältnisse. Fig. 28 zeigt das Thema des Ornaments: eine Reihe von Punkten, die sich regelmässig und horizontal wiederholen und von zwei Linien eingefasst sind. Das Motiv ist ausgesprochen klein im Verhältnis zur gegebenen Fläche. Bei den Fig. 29, 30 und 31 ist das Verhältnis genau umgekehrt: das Ornament nimmt zunehmend den ganzen Raum ein. Dieses einfache Beispiel zeigt, dass Ornament-Motive gleicher Konstruktion und gleichförmiger Elemente jeweils vollkommen verschieden aussehen können. Vom Motiv hängt auch die Wirkung der geschmückten Fläche ab. Betrachten wir die Fig. 32 u. 33, so haben wir das Empfinden, dass die Rechtecke, die mit einem von Fäden umrahmten Band verziert sind, sich voneinander unterscheiden. Dasjenige der Fig. 33 erscheint uns gedrungener und kürzer und doch sind in Wirklichkeit beide genau gleich gross. Das erklärt sich daraus, dass die Lage des Ornament-Motivs die optische Wirkung der Fläche verändert (Fig. 7 u. 8).

Zu bemerken ist noch, dass die folgenden 1000 Ornament-Motive sämtlich zweidimensional gezeichnet wurden. Wir haben über ein Drittel der räumlichen Motive in diesem Sinne vereinfacht. Es ist im übrigen interessant, den Formwandel zu studieren, der mit dem Verlassen der dritten Dimension auftritt.

Die nachfolgenden Beispiele wiederum zeigen deutllich, wie ein Motiv sich bei der Anpassung an veränderte räumliche Bedingungen, d. h. wenn es dreidimensional wird, ändert (Fig. 34, 35, 36).

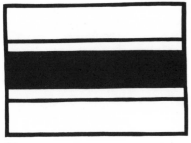

32

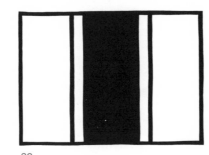

33

34

34

34

35

36

32, 33 : Influence de l'ornement sur une surface.
En fonction d'une division verticale ou
horizontale, la surface change optiquement
de forme.
34 : Adaptation d'un motif sur un cône: plan,
profil et développement. Coupe préhisto-
rique, Persépolis.
35, 36 : Réaction visuelle de motifs simples
adaptés sur un cylindre.

*32, 33 : The influence of ornament on a surface;
subdivided differently, the background form
appears to change proportions.*
*34 : The effect of applying a design to the surface
of a cone: plan and elevation of cone, and
whole design. Prehistoric, Persepolis.*
*35, 36 : The effect of applying simple designs
to a cylindrical surface.*

32, 33 : Wirkung des Ornaments auf eine Fläche.
Durch die vertikale oder horizontale Ein-
teilung verändert die Fläche optisch ihre
Form.
34 : Anpassung eines Motivs auf einen Kegel:
Grundriss, Profil und Ausführung. Prähisto-
rische Trinkschale. Persepolis.
35, 36 : Optische Wirkung einfacher Motive, die
auf einem Zylinder angewandt werden.

19

Les techniques utilisées par les créateurs sont non seulement multiples, mais elles ont dans une très forte mesure influencé le graphisme des motifs ornementaux. La matière sur laquelle les artistes ont travaillé, ainsi que les instruments utilisés pour transcrire leur vision décorative, déterminent le caractère des motifs. L'évolution technique peut être comparée à celle de l'écriture dont nous donnons deux exemples. Nous avons choisi le signe astre, ciel, dieu, de l'écriture cunéiforme suméro-akkadienne, dont l'évolution s'est faite durant près de trois millénaires. On peut constater dans cette transformation que, contrairement à l'évolution du motif soleil dont nous avons précédemment parlé (fig. 4), l'élément symbolique se transforme en un signe graphique conventionnel. Ce sont les exigences techniques qui ont été impératives: d'une part la dimension des tablettes d'argile, primitivement petites et maniables, par la suite de grande

The techniques used by artists have strongly influenced the form of ornamental design. The character of the motif is largely determined by the material on which the artist works and by the tools which he uses to transcribe his vision. The influence of technique may be illustrated by two examples from the history of writing; in the course of nearly three thousand years, the sign which means ' heavenly body ', ' sky ' and ' god ' in the cuneiform script of Sumeria and Akkadia gradually transformed itself from a symbol into a conventional graphic sign (Figs 37–39). This evolution is the reverse of that undergone by the sun symbol (Fig. 4), and is entirely the product of technical factors: the replacement of small, portable clay tablets by large, fixed ones, and that of the round-pointed stylus by a reed with the tip cut into a triangular shape. Medieval handwriting provides

Die von den Künstlern angewandten Techniken sind sehr verschiedenartig und beeinflussen weitgehend die Graphik der Ornament-Motive. Ihr Charakter wird nicht nur durch das verwendete Material, sondern auch durch die Werkzeuge geprägt, deren sich die Künstler bedienen. Die handwerkliche Entwicklung kann mit der Entwicklung der Schrift verglichen werden, wofür wir zwei Beispiele anführen.

Wir haben das Symbol für Gestirn, Himmel, Gott in der sumero-akkadischen Keilschrift gewählt, dessen Entwicklung sich über nahezu drei Jahrtausende erstreckte. Dabei kann man feststellen, dass es sich im Gegensatz zur Entwicklung des Sonnenzeichens (Fig. 4) in ein konventionelles, graphisches Zeichen verwandelt. Ausschlaggebend hierfür waren die technischen Gegebenheiten: einerseits das Format der Tontafeln, die ursprünglich klein und handlich, später gross und unbeweglich

37, 38, 39: Evolution, sur près de trois millénaires, de l'écriture cunéiforme suméro-akkadienne. Le symbole devient signe conventionnel.

40: Extrait d'un alphabet gothique. La plume régit la rigueur de l'écriture. Début du XV^me siècle.

37, 38, 39: Development of the Sumero-Akkadian cuneiform glyph over almost three thousand years; the symbol becomes an ideograph.

40: Part of Gothic alphabet; the pen determines the severe outline of the letter forms. Europe, early 15th century.

37, 38, 39: Entwicklung der sumerisch-akkadischen Keilschrift über fast drei Jahrtausende. Das Symbol wird zum konventionellen Schriftzeichen.

40: Auszug aus einem gotischen Alphabet. Die flache Feder bestimmt die Strenge der Schrift. Auch in anderen Techniken, wie z. B. im Steinschnitt, bleibt der durch die Feder bedingte Schriftcharakter erhalten. 1410.

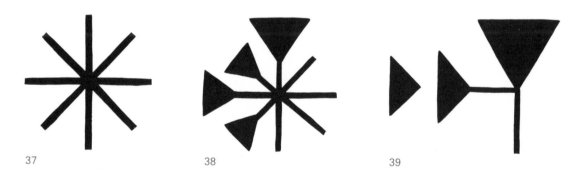

37 38 39

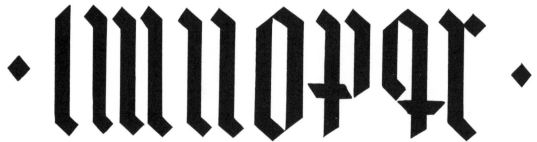

40

dimension et fixes; d'autre part le changement d'instruments: calame, poinçon à bout rond, puis roseau taillé en biseau (fig. 37, 38 et 39). La fig. 40 nous montre des caractères gothiques tracés à la plume plate, celle-ci définissant la rigueur de l'écriture.

Les exemples de motifs ornementaux conditionnés par la technique sont innom-

another instance of this; the form of the letters in the example illustrated is determined by the use of a chisel-tipped pen (Fig. 40). There are innumerable examples of ornamental motifs conditioned by technique; the most interesting cases are those in which the artist has been able to master and transcend technical

waren, anderseits die Veränderung des Handwerkszeugs, Schreibrohr, Meissel mit rundem Ende, dann Schilfrohr mit schräger Kante (Fig. 37, 38, 39). Fig. 40 zeigt uns gotische Buchstaben, mit stumpfer Feder gezeichnet, durch die der Charakter der Schrift bestimmt wird.

Es gibt unzählige Ornament-Motive, deren Ursprung aus einer bestimmten Technik abzuleiten ist und die durch den

41

42

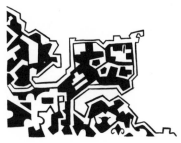

43

41: Motif ornemental en perles. La technique conditionne le graphisme. Dakotas, Amérique du Nord.
42: Motif issu d'un tissage grossier. Congo.
43: Ornement d'un tapis. XVIIᵐᵉ siècle, Anatolie.
44, 45: Motifs ornementaux caractéristiques du tressage. Congo.
46: Ornement exécuté au pinceau. Indiens Zounis, Amérique du Nord.

41: Beadwork motif; technique determines form. Dakota Indians, North America.
42: Motif based on rudimentary woven texture. Congo.
43: Motif from a carpet. Anatolia, Turkey, 17th century.
44, 45: Motifs characteristic of basketwork or strapwork. Congo.
46: Design produced with paintbrush. Zuñi Indians, New Mexico, U.S.A.

44

45

46

41: Muster aus Perlen. Die Technik bedingt die Graphik. Dakota-Indianer, Nordamerika.
42: Motiv von einem groben Gewebe, Kongo.
43: Ornament eines Teppichs, XVII. Jahrh., Anatolien, Türkei.
44-45: Ornament-Motive eines Flechtwerks, charakteristisch für den Kongo.
46: Mit Pinsel ausgeführtes Ornament, Zuni-Indianer, Nordamerika.

brables et du plus haut intérêt chaque fois que le créateur a su dominer ces exigences pour s'exprimer librement. Nous nous limitons donc à quelques exemples typiques de diverses techniques: perles (fig. 41), tissage (fig. 42), tapis (fig. 43), tressage (fig. 44 et 45), pinceau (fig. 46), ce dernier permettant une grande liberté d'expression.

requirements in order to express himself with complete freedom. We shall limit ourselves here to illustrating a few examples which are characteristic of particular techniques: beads (Fig. 41), weaving (Fig. 42), tapestry (Fig. 43), basketwork (Figs 44 and 45) and brushwork (Fig. 46); the last-named permits a particularly wide expressive variety.

Künstler frei umgestaltet wurden. Wir beschränken uns auf einige typische Beispiele für verschiedene Techniken: Perlenstickerei (Fig. 41), Gewebe (Fig. 42), Teppiche (Fig. 43), Flechtwerk (Fig. 44 u. 45), Pinseltechnik (Fig. 46), wobei besonders letztere über sehr grosse Ausdrucksmöglichkeiten verfügt.

Avec l'évolution de notre civilisation, la technique au XXᵉ siècle a pris une tout autre signification. Le motif ornemental est créé dans la plupart des cas en fonction d'une reproduction en série et ceci dans de nombreux domaines: art graphique, architecture, industrie, textile, etc... Le motif ornemental n'est plus gratuit, il est devenu fonctionnel, et représente une unité qui, répétée à de nombreux exemplaires parfaitement reproduits, est à l'image du monde moderne.

The twentieth century, with its vast expansion of the range of available techniques, has brought about a fundamental change. The ornamental motif is created, in the majority of cases, with a view to mechanical mass reproduction, in print, textile, wood, metal, plastic or other industrial material. The ornamental motif is no longer gratuitous; it has become functional, representing a unit which, reproduced accurately and in quantity, is the image of the rhythm of modern life.

Mit der fortschreitenden Zivilisation hat schliesslich auch die Technik im 20. Jahrhundert eine völlig andere Bedeutung gewonnen. Das Motiv entsteht meistens durch serienmässige Reproduktion, und zwar in vielen Bereichen: in der graphischen Kunst, in der Architektur, in der Industrie usw. Das Ornament-Motiv ist nicht länger eine Zugabe; es erhält eine Funktion und wird — etwa im Profil der Kunststoffschuhsohle — vieltausendfach angewendet ein Stück alltäglicher Gegenwärtigkeit.

47: Pont pour piétons, motif ornemental à grande échelle. Japon.
47-A: Echangeur couvrant 68 hectares. Le motif ornemental, né du trafic automobile actuel, devient gigantesque. Michigan, U.S.A.
48: Eléments de carrelage fabriqués en série. Type du motif ornemental adapté à une fonction. Italie.

47: Footbridge; ornament on a gigantic scale. Japan, 20th century.
47 A: Highway junction covering 170 acres; the ornamental motif, here a product of motor transport, takes on huge dimensions. Michigan, U.S.A., 20th century.
48: Mass-produced tiles; a typical instance of the adaptation of ornament to function. Italy, 20th century.

47: Fussgängerbrücke. Ornament-Motiv in grossem Masstab. XX. Jahrh., Japan.
47 A: Verkehrskreuzung, 68 Hektar umfassend. Das aus dem heutigen Autoverkehr hervorgegangene Motiv wächst ins Riesenhafte. Michigan, U.S.A.
48: Grundformen für Fliesen in Serienherstellung. Der Typus des Motivs ist seinem Zweck angepasst. XX. Jahrh., Italien.

47

47 A

48

48

49

49

50

50

49: Eléments de carrelage fabriqués en série. Type du motif ornemental adapté à une fonction. Italie.
50: Eléments ajourés destinés à l'architecture et utilisés pour la construction de murs qui laissent filtrer la lumière. La fonction crée le motif ornemental. Italie.

49: *Mass-produced tiles; a typical instance of the adaptation of ornament to function. Italy, 20th century.*
50: *Units designed for openwork walls; here the function creates the ornemental motif. Italy, 20th century.*

49: Grundformen für Fliesen in Serienherstellung. Der Typus des Motivs ist seinem Zweck angepasst. XX. Jahrh., Italien.
50: Durchbrochene Grundformen für die Architektur. Angewandt bei Mauern, die Licht eindringen lassen sollen. Der Zweck schafft das Ornament-Motiv. XX. Jahrh., Italien.

Le motif passe très souvent de son but purement décoratif à un but utilitaire sans perdre pour autant sa qualité de beauté et de création intégrées dans une société dynamique où l'évolution se fait avec des raccourcis surprenants. Souvent, la fonction crée le motif ornemental qui peut prendre des dimensions jusqu'ici inattendues. Nous pensons, entre autres, aux tracés du système routier (fig. 47 et 47 A).

Dans l'architecture, où le problème était déjà apparent dans les siècles qui nous ont précédés, le motif ornemental devient

In the context of a dynamic society in which evolution proceeds by a series of short cuts, the ornamental motif often shifts from a purely decorative function to a utilitarian one without necessarily losing its aesthetic and creative content. Often the function creates the motif, which may be on an unprecedented scale, as in the patterns formed by modern road junctions (Figs 47 and 47A). In architecture, where the problem of the integration of ornament into an industrial process has been apparent for centuries, the ornamental motif has now finally become dependent on rational,

Das Ornament erfährt so häufig eine Wandlung vom nur Dekorativen zum Zweckmässigen, ohne dabei seine Schönheit einzubüssen oder seine künstlerische Herkunft zu verraten. So erweckt das Luftbild einer Autobahnkreuzung durchaus den Eindruck eines funktionell entstandenen Ornaments (Fig. 47 u. 47 A).

51 : Eléments ajourés destinés à l'architecture et utilisés pour la construction de murs qui laissent filtrer la lumière. La fonction crée le motif ornemental. Italie.

51: Units designed for openwork walls; here the function creates the ornamental motif. Italy, 20th century.

51 : Durchbrochene Grundformen für die Architektur. Angewandt bei Mauern, die Licht eindringen lassen sollen. Der Zweck schafft das Ornament-Motiv. XX. Jahrh., Italien.

51

51

tributaire d'une fabrication rationnelle et normalisée (fig. 48, 49, 50 et 51). Dans certains domaines, comme la céramique (poterie), il a cédé la place à la forme et a pratiquement disparu. Dans les textiles, par contre, il n'a jamais été d'une telle invention et d'une telle audace. L'art graphique y joue un rôle prépondérant. La peinture elle-même devient, dans une certaine mesure, une recherche ornementale sur le plan optique, graphique et rythmique (fig. 52 et 53). Les recherches de Vasarely en sont une des démonstrations les plus caractéristiques.

standardized production methods (Figs 48–51). In certain fields, such as ceramics, ornament has almost entirely disappeared, and designers concentrate their attention on external form. In textiles, on the other hand, ornamental design now displays more inventiveness and more audacity than ever before. The development of graphic art plays a preponderant part in this. Painting itself has become, to some extent, a form of decorative experimentation in optical, graphic and rhythmic effects (Figs 52 and 53). The optical experiments of Vasarely provide one of the most characteristic demonstrations of this tendency.

Mit der Forderung nach unbedingter Sachlichkeit moderner Architektur wurde am Bau das Ornament weitgehend verbannt. Adolf Loos schrieb um 1900, Ornament sei Verbrechen. In der Architektur der Gegenwart jedoch ist das Ornament bereits wieder aufgewertet. So werden unter anderem Betonformsteine als ornamentaler Flächenschmuck verwendet. Hier aber ist das Ornament-Motiv von einer rationellen und genormten Herstellung abhängig (Fig. 48, 49, 50, 51). In gewissen Bereichen, wie der Keramik, ist es dagegen praktisch verschwunden. Form erscheint wichtiger als Ornament. Im Bereich der Textilien hinwiederum, Orientteppiche ausgenommen, hatte es von Anfang an keine solche Fülle von vielgestaltigen und kühnen Ornamenten gegeben. Die entscheidende Rolle spielt dort die Graphik. Die Malerei selbst spürt in gewissem Grad dem Ornament auf der optischen, graphischen und rhythmischen Ebene nach (Fig. 52 u. 53). Die besten Belege dafür finden sich in den Untersuchungen Vasarelys.

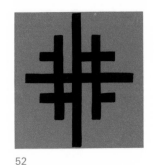

52

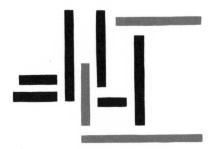

53

52: Motif ornemental très graphique de conception, rythmé par le rapport des verticales et des horizontales. Textile moderne, Danemark.
53: Recherches parallèles à celle de la figure 52, effectuées sur une même base rythmique. Détail d'une œuvre du peintre Théo van Doesburg.

52: Motif with strong graphic basis; the rhythm is created by the relationship between horizontals and verticals. Textile design, Denmark, 20th century.
53: Use of the same basic rhythm as in Fig. 52; detail of a painting by Theo van Doesburg, 20th century.

52: Ornament-Motiv von streng graphischer Auffassung; rhythmisch durch die Übereinstimmung der Senkrechten und Waagrechten. Gewebe. XX. Jahrh., Dänemark.
53: Detail aus einem Werk des Malers Theo von Doesburg. Graphische Abwandlung der Fig. 52 nach gleichem rhythmischen Grundsatz.

Nous vivons ainsi une époque passionnante où souvent la fonction crée le motif ornemental. N'est-il pas curieux de comparer les profils de pneus de 1969 (fig. 54) ou un extrait de fiche d'ordinateur (fig. 56) aux motifs ornementaux de peuples primitifs ou de civilisations qui ont précédé l'ère chrétienne (fig. 55 et 57)? Les démarches en sont différentes et les résultats nous démontrent que, dans le domaine de la création, tout n'est qu'éternel recommencement!

We live in an exciting age, in which function, more than ever before, is the ally of imagination. It is curious to be able to compare the tread pattern of a 1969 motor tyre (Fig. 54) or a piece of punched tape from a computer (Fig. 56) with the ornamental designs of primitive peoples and of civilizations which are older than the Christian era (Figs 55 and 57). The initial actions involved are different, but the results demonstrate that in the domain of creativity the process of renewal has no end.

Es ist erregend zu sehen, dass heute rein funktionelle Zwecke neue Ornament-Motive entstehen lassen. Hat es nicht einen eigenartigen Reiz, die Profile von Autoreifen (Fig. 54) oder den Auszug eines Lochkartenstreifens (Fig. 56) mit Ornament-Motiven primitiver Völker oder vorchristlicher Kulturen zu vergleichen (Fig. 55 u. 57)? Wie sehr sie sich auch voneinander unterscheiden, führen sie doch zu der Erkenntnis, dass auf dem Gebiet des Schöpferischen alles immer nur Wiederbeginn ist.

54

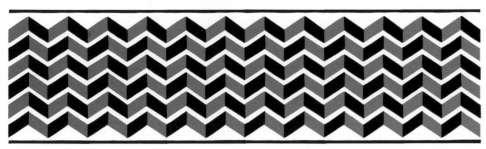

55

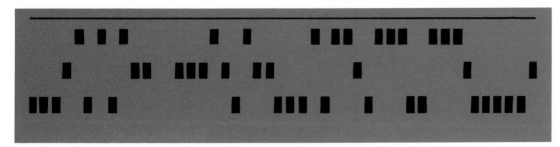

56

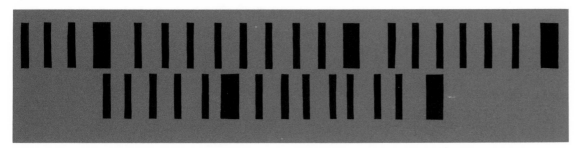

57

54 : Profil actuel de pneu spécialement dessiné pour éviter l'aquaplaning. La fonction crée le motif ornemental et retrouve un rythme primitif tel que celui exprimé en figure 55.
55 : Ornement en chevrons, Congo.
56 : Schéma modulaire partiel d'enregistrement des communications d'un ordinateur. La répétition irrégulière d'un motif identique crée le rythme dont se dégage le caractère ornemental. Il est intéressant de comparer ce motif absolument fonctionnel avec celui de la figure 57 qui reprend le motif mycénien présenté en début de cette étude.
57 : Motif mycénien, 2me millénaire av. J.-C., Tirynthe, Grèce.

54: Tread of tyre designed to eliminate aquaplaning; function creates the ornamental motif and creates a primitive rhythm similar to that contained in Fig. 55.
55: Chevron ornament. Congo.
56: Section of punched tape from a computer. The irregular repetition of a single motif creates a rhythm which in turn produces the ornamental effect. This purely functional pattern may be compared with the Mycenean motif in Fig. 57.
57: Mycenean motif. Tiryns, Greece, 2nd millennium BC.

54 : Profil eines Autoreifens als Gleitschutz. Der Zweck schafft das Ornament-Motiv und geht auf einen primitiven Rhythmus zurück, ähnlich wie in Fig. 55.
55 : Ornament aus Sparren, Kongo.
56 : Ausschnitt einer Lochkarte zum Füttern eines Komputers. Die unregelmässige Wiederholung des gleichen Motivs schafft den Rhythmus, der den Charakter des Ornaments bestimmt. Man vergleiche dieses rein funktionelle Motiv mit Fig. 57, die das mykenische Motiv vom Beginn dieser Studie aufgreift.
57 : Mykenisches Motiv, 2. Jahrtausend v. Chr., Tiryns, Griechenland.

**Motifs ornementaux
de structure
carrée et rectangulaire**

Rectilinear ornaments

**Quadratische und rechteckige
Ornament-Motive**

58

58

59

59

60

60

61

61

62: Frise, Hawaii.
63: Amphore, VIII^me siècle av. J.-C., Grèce.
64: Amphore, VIII^me siècle av. J.-C., Grèce.
65: Amphore, VIII^me siècle av. J.-C., Grèce.

62: Frieze motif. Hawaii.
63: Motif from amphora. Greece, 8th century BC.
64: Motif from amphora. Greece, 8th century BC.
65: Motif from amphora. Greece, 8th century BC.

62: Fries, Hawai.
63: Amphore, VIII. Jahrh. v. Chr., Griechenland.
64: Amphore, VIII. Jahrh. v. Chr., Griechenland.
65: Amphore, VIII. Jahrh. v. Chr., Griechenland.

62

63

63

64

64

65

65

66

66

67

67

68

68

69

70

71 : Motif ornemental, Berbères, Afrique du Nord.
72 : Motif architectural, époque précolombienne, Mitla, Mexique.
73 : Motif ornemental, Asie Mineure.
74 : Motif ornemental, VIII^me-IX^me siècle, Mayas, Yucatan, Mexique.

71: Berber motif. North Africa.
72: Stonework frieze motif. Mitla, Precolumbian Mexico.
73: Asia Minor.
74: Maya motif. Yucatán, Mexico, 8th-9th centuries.

71 : Berberei, Nordafrika.
72 : Architektonisches Motiv, prä-kolumbianisch, Mitla, Mexiko.
73 : Kleinasien.
74 : VIII.-IX. Jahrh., Maya, Yukatan, Mexiko.

71

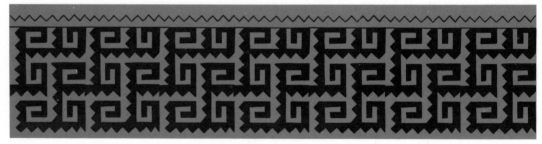
72

73

74

75

75

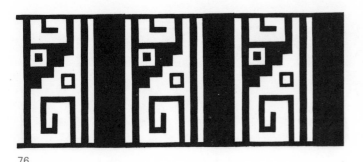

76

77

78

79

80

81

82: Motif ornemental, XIXme siècle, Bulgarie.
83: Vase rituel, XIme siècle av. J.-C., Chine.
84: Frise, XVIIIme siècle, Chine.
85: Motif ornemental, 5me millénaire av. J.-C., Halaf, Mésopotamie.
86: Tressage, Congo.
87: Motif ornemental symbolique (signe de longévité), XVIIme siècle, Chine.

82: Bulgaria, 19th century.
83: Motif from cult vessel. China, 11th century BC.
84: Frieze motif. China, 18th century.
85: Halaf, Mesopotamia, 5th millennium BC.
86: Strapwork motif. Congo.
87: Emblem of longevity. China, 17th century.

82: XIX. Jahrh., Bulgarien.
83: Kultisches Gefäss, XI. Jahrh. v. Chr., China.
84: Fries, XVIII. Jahrh., China.
85: 5. Jahrtausend v. Chr., Halaf, Mesopotamien.
86: Flechtwerk, Kongo.
87: Symbol hohen Lebensalters, XVII. Jahrh., China.

82

83

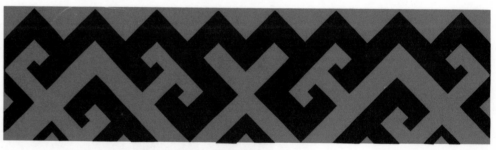

84

85

86

87

88

89

90

88: Sauvastika (croix gammée), époque pré-hittite, 3me millénaire av. J.-C.
89: Motif ornemental, époque précolombienne, Incas, Pérou.
90: Motif ornemental, Rhodes, Grèce.
91: Motif ornemental, Rhodes, Grèce.
92: Motif ornemental, Rhodes, Grèce.
93: Motif ornemental, Rhodes, Grèce.
94: Motif ornemental, Halaf, Mésopotamie.
95: Ossuaire, VIIIme siècle av. J.-C., Italie du Sud.
96: Svastika (croix gammée), Asie Mineure.
97: Sauvastika (croix gammée), art romain, Chedworth, Angleterre.

91

92

93

88: *Pre-Hittite sauvastika. Asia Minor, 3rd millennium BC.*
89: *Inca motif. Precolumbian Peru.*
90: *Rhodes, Ancient Greece.*
91: *Rhodes, Ancient Greece.*
92: *Rhodes, Ancient Greece.*
93: *Rhodes, Ancient Greece.*
94: *Halaf, Mesopotamia.*
95: *From an ossuary. South Italy, 8th century BC.*
96: *Swastika. Asia Minor.*
97: *Roman sauvastika. Chedworth, England.*

94

94

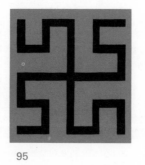

95

88: Sauvastika (Hakenkreuz), prä-hethitisch, 3. Jahrtausend v. Chr.
89: Inka, Peru.
90: Rhodos, Griechenland.
91: Rhodos, Griechenland.
92: Rhodos, Griechenland.
93: Rhodos, Griechenland.
94: Halaf, Mesopotamien.
95: Beinhaus, VIII. Jahrh. v. Chr., Süditalien.
96: Svastika (Hakenkreuz), Kleinasien.
97: Sauvastika (Hakenkreuz), römisch, Chedworth, England.

96

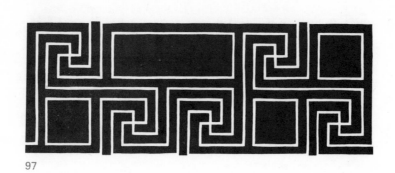

97

98: Mosaïque, époque des Ptolémées, Délos, Grèce.
99: Sauvastika (croix gammée), art romain, Woodchester, Angleterre.
100: Svastika (croix gammée), Chine.

98: From a mosaic. Delos, Greece, Ptolemaic period.
99: Roman sauvastika. Woodchester, England.
100: Swastika. China.

98: Mosaik, ptolemäisch, Griechenland.
99: Sauvastika (Hakenkreuz), römisch, Woodchester, England.
100: Swastika (Hakenkreuz), China.

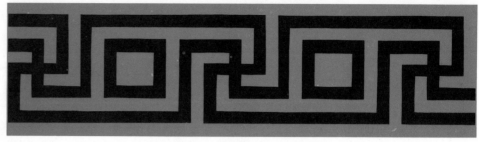

98

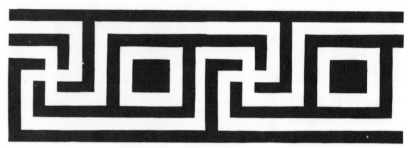

98

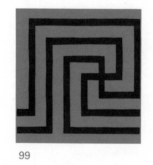

99

99

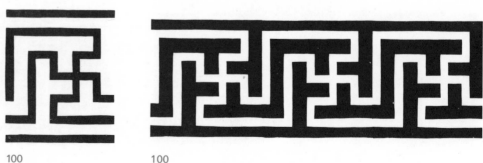

100

100

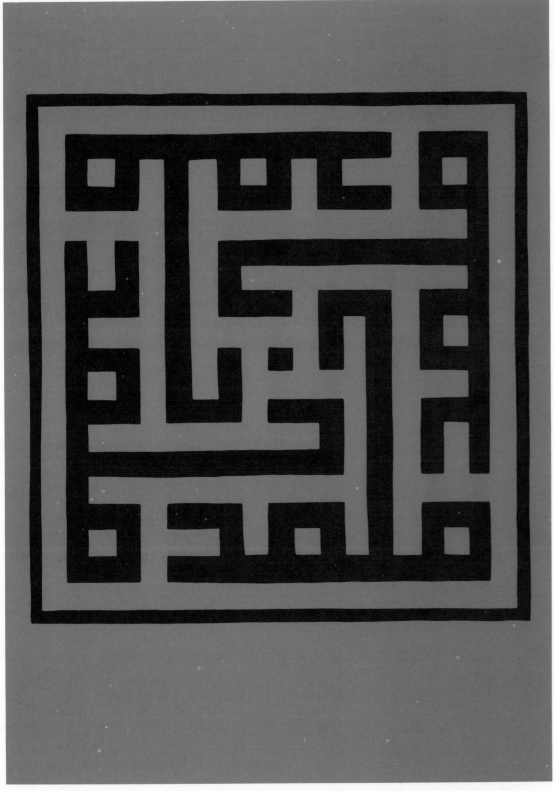

101

101 : Nom de Mahomet répété quatre fois en écriture koufique, art musulman, Turquie.

101 : Name of Mohammed repeated four times in Kufic script. Turkey.

101 : Der Name Mohammeds viermal in kufischer Schrift wiederholt, muselmanisch, Türkei.

102: Motif ornemental, XVIIᵐᵉ siècle, Chine.
103: Frise, Chine.
104: Mosaïque, art romain, Pompéi, Italie.

102: China, 17th century.
103: Frieze motif. China.
104: Roman mosaic motif. Pompeii, Italy.

102: XVII. Jahrh., China.
103: Fries, China.
104: Mosaik, römisch, Pompeji, Italien.

102

102

103 103

104 104

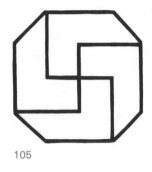

105

105

105: Mosaïque, art romain, Pompéi, Italie
106: Motif ornemental, Sarnath, Inde.

105: Roman mosaic motif. Pompeii, Italy.
106: Sarnath, India.

105: Mosaik, römisch, Pompeji, Italien.
106: Sarnath, Indien.

106

106

107: Motif ornemental, époque précolombienne,
Pérou.
108: Motif ornemental, époque précolombienne,
Incas, Pérou.
109: Motif ornemental, Toltèques, Tula, Mexique.
110: Céramique, époque précolombienne, Pérou.

107: *Precolumbian Peru.*
108: *Inca motif. Precolumbian Peru.*
109: *Toltec motif. Tula, Precolumbian Mexico.*
110: *Ceramic motif. Precolumbian Peru.*

107: Prä-kolumbianisch, Peru.
108: Prä-kolumbianisch, Inka, Peru.
109: Toltekisch, Tula, Mexiko.
110: Keramik, prä-kolumbianisch, Peru.

107

108

109

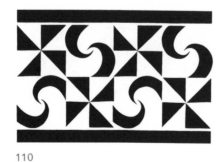
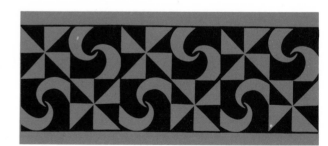

110 110

111

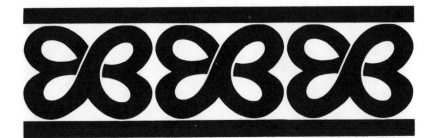

111

112

112

113

114

115

116

117

118: Tissu, Bakubas, Congo.
119: Tissu, Bakubas, Congo.

118: *Bakuba textile motif. Congo.*
119: *Bakuba textile motif. Congo.*

118: Gewebe, Bakuba, Kongo.
119: Gewebe, Bakuba, Kongo.

118

118

119

119

120

120

120: Motif ornemental, Bakubas, Congo.
121: Mosaïque, art romain, Autriche.

120: Bakuba motif. Congo.
121: Roman mosaic motif. Austria.

120: Bakuba, Kongo.
121: Mosaik, römisch, Österreich.

121

121

122: Motif ornemental, époque préhittite, 3ᵐᵉ millénaire av. J.-C.
123: Motif ornemental, Mayas, Uxmal, Yucatan, Mexique.

122: Pre-Hittite motif. Asia Minor, 3rd millennium BC.
123: Maya motif. Uxmal, Yucatán, Precolumbian Mexico.

122: Prä-hethitisch, 3. Jahrtausend v. Chr.
123: Maya, Uxmal, Yukatan, Mexiko.

122

122

123

123

124

124

124: Motif architectural, XXᵐᵉ siècle, Italie.
125: Motif ornemental, Amritsar, Inde.

124: *Openwork wall design. Italy, 20th century.*
125: *Amritsar, India.*

124: Architektonisches Motiv, XX. Jahrh., Italien.
125: Amritsar, Indien.

125

125

126: Motif ornemental, Bakubas, Congo.
127: Motif ornemental, Nouvelle-Guinée.
128: Motif ornemental, tribu Fengo, îles Tonga, Polynésie.
129: Motif ornemental, art copte, Egypte.
130: Tissu, époque pharaonique, Egypte.

126: *Bakuba motif. Congo.*
127: *New Guinea.*
128: *Fengo motif. Tonga Islands, Polynesia.*
129: *Coptic motif. Egypt.*
130: *Textile motif. Ancient Egypt.*

126: Bakuba, Kongo.
127: Neu-Guinea.
128: Fengo-Stamm, Tonga-Inseln, Polynesien.
129: Koptisch, Ägypten.
130: Gewebe, pharaonisch, Ägypten.

126 126

127

128

129 129

130

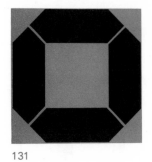

131

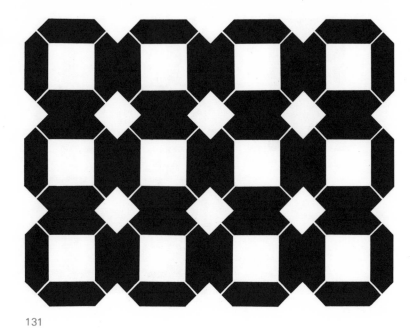

131

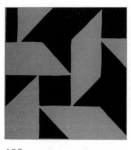

132

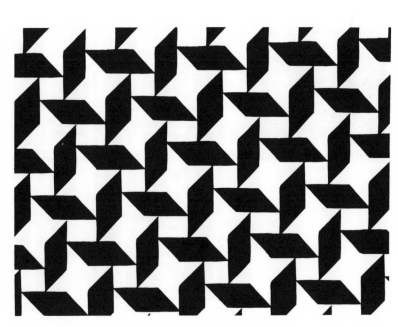

132

131: Céramique, XXᵐᵉ siècle, Italie.
132: Motif ornemental, école d'Akbar, XVIᵐᵉ siècle, Moghols, Inde.

131: Ceramic design. Italy, 20th century.
132: Mogul motif of Akbar school. India, 16th century.

131: Keramik, XX. Jahrh., Italien.
132: Akbar-Schule, XVI. Jahrh., Moghulzeit, Indien.

133: Motif architectural, XXᵐᵉ siècle, Italie.
134: Mosaïque, art romain.

133: Openwork wall design. Italy, 20th century.
134: Roman mosaic motif.

133: XX. Jahrh., Italien.
134: Mosaik, römisch.

133

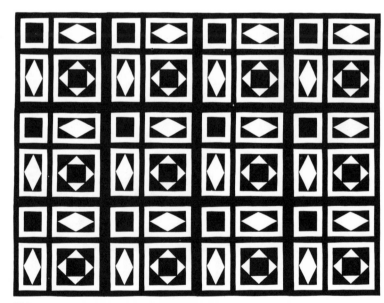

133

134

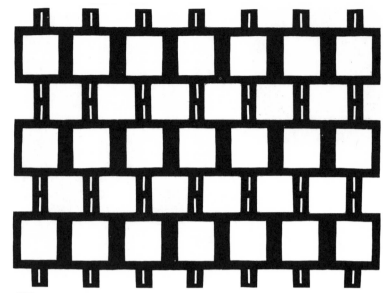

134

135

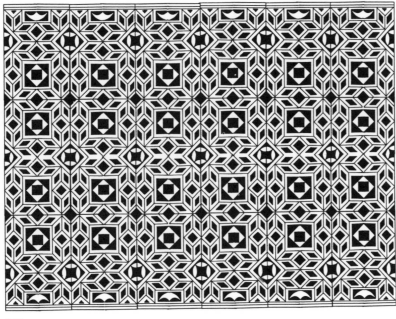

135

135: Mosaïque, art romain, Nîmes, France.
136: Tissu, îles Fidji, Mélanésie.

135: Roman mosaic motif. Nîmes, France.
136: Textile motif. Fiji, Melanesia.

135: Mosaik, römisch, Nîmes, Frankreich.
136: Gewebe, Fidschi-Inseln, Melanesien.

136

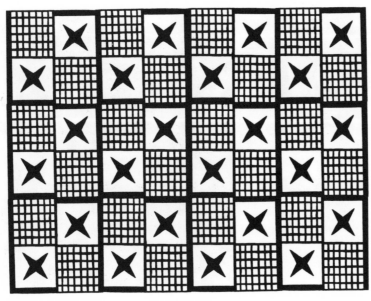

136

137: Motif ornemental, VIIIᵐᵉ-IXᵐᵉ siècle, Mayas, Uxmal, Yucatan, Mexique.
138: Motif ornemental, art roman.

137: Maya motif. Uxmal, Yucatán, Mexico, 8th-9th centuries.
138: Romanesque motif.

137: VIII. - IX. Jahrh., Maya, Uxmal, Yukatan, Mexiko.
138: Romanisch.

137

137

138

138

139

140

141

141

142

142

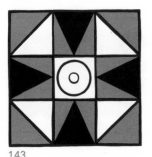

143

144

145

146: Motif ornemental, XVIᵐᵉ siècle, Italie.
147: Perles, Indiens Dakotas, Amérique du Nord.
148: Motif ornemental, perles, Guyane.
149: Motif ornemental, XVIᵐᵉ siècle, Lahore, Pakistan.

146: Italy, 16th century.
147: Dakota Indian beadwork motif. North America.
148: Beadwork motif. Guyana.
149: Frieze motif. Lahore, Pakistan, 16th century.

146: XVI. Jahrh., Italien.
147: Perlen, Dakota-Indianer, Nordamerika.
148: Perlen, Guayana.
149: XVI. Jahrh., Lahore, Pakistan.

146

146

147

148

149

149

150

150

150: Motif ornemental, Bornéo.
151: Motif ornemental, art copte, Egypte.
152: Motif ornemental XVIIᵐᵉ siècle, Vietnam.
153: Motif ornemental, XXᵐᵉ siècle, Japon.

150: Borneo.
151: Coptic motif. Egypt.
152: Vietnam, 17th century.
153: Japan, 20th century.

150: Borneo.
151: Koptisch, Ägypten.
152: XVII. Jahrh., Vietnam.
153: XX. Jahrh., Japan.

151

151

152

152

153

153

154: Motif ornemental, Japon.
155: Motif ornemental, Indiens Penobscots, Maine, U.S.A.
156: Motif ornemental, Japon.
157: Motif ornemental indien, Amérique du Nord.
158: Motif ornemental, Indiens Penobscots, Maine, U.S.A.
159: Tissu indien, Panama.

154: Japan.
155: Penobscot Indian motif. Maine, U.S.A.
156: Japan.
157: Indian motif. North America.
158: Penobscot Indian motif. Maine.
159: Indian textile motif. Panama.

154: Japan.
155: Motiv der Penobscots-Indianer, Maine, USA.
156: Japan.
157: Indianisches Ornament-Motiv, Nordamerika.
158: Indianisches Ornament-Motiv, Penobscots, Maine, USA.
159: Indianisches Gewebe, Panama.

154

154

155

156

157

158

159

160

161

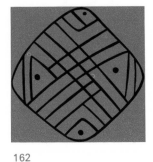

162

163

163

164

165

166

167

168

160: Encadrement (P. Durouchail), gravure sur cuivre, XIX^me siècle, Paris, France.
161: Encadrement (P. Durouchail), gravure sur cuivre, XIX^me siècle, Paris, France.
162: Motif ornemental, 4^me millénaire av. J.-C., Obeid, Mésopotamie.
163: Motif ornemental, art arabe.
164: Mosaïque, Istanbul, Turquie.
165: Motif ornemental, 4^me millénaire av. J.-C., Mésopotamie.
166: Motif ornemental, préhistoire, Tennessee, U.S.A.
167: Pont pour piétons, XX^me siècle, Japon.
168: Echangeur d'autoroute, XX^me siècle, Michigan, U.S.A.

160: Ornamental border, copper engraving by P. Durouchail. Paris, France, 19th century.
161: Ornamental border, copper engraving by P. Durouchail. Paris, France, 19th century.
162: Obeid, Mesopotamia, 4th millennium BC.
163: Arab motif.
164: Mosaic. Istanbul, Turkey.
165: Mesopotamia, 4th millennium BC.
166: Prehistoric motif. Tennessee, U.S.A.
167: Footbridge. Japan, 20th century.
168: Highway junction. Michigan, U.S.A., 20th century.

160: Umrahmung (P. Durouchail), graviertes Kupfer, XIX. Jahrh., Paris, Frankreich.
161: Umrahmung (P. Durouchail), graviertes Kupfer, XIX. Jahrh., Paris, Frankreich.
162: 4. Jahrtausend v. Chr., Obeid, Mesopotamien.
163: Arabisches Ornament-Motiv.
164: Mosaik, Istanbul, Türkei.
165: 4. Jahrtausend v. Chr., Mesopotamien.
166: Prähistorisch, Tennessee, USA.
167: Fussgänger-Brücke, XX. Jahrh., Japan.
168: Autobahn-Kreuzung, XX. Jahrh., Michigan, USA.

169: Motif ornemental, XVIᵐᵉ siècle, Allemagne.
170: Motif ornemental, archipel malais.

169: Germany, 16th century.
170: Malay Archipelago.

169: XVI. Jahrh., Deutschland.
170: Malaischer Archipel.

169

169

170

170

171

172

173

174

174

175

176

177

178

179: Motif ornemental, Indiens Chippewas, Amérique du Nord.
180: Motif ornemental, Indiens, Amérique du Nord.
181: Motif ornemental, XVIIᵐᵉ siècle, Finlande.
182: Motif ornemental, Océanie.
183: Motif ornemental, XIXᵐᵉ siècle, Norvège.
184: Encadrement de serrure, XVIᵐᵉ siècle, France.
185: Encadrement de serrure, XVIᵐᵉ siècle, France.
186: Lyre, Empire, France.
187: Motif ornemental, Indiens Kwakiutls, côte nord-ouest, Amérique du Nord.
188: Flambeau, Empire, France.
189: Motif ornemental, XIXᵐᵉ siècle, Finlande.
190: Motif ornemental, Indiens Panamints, Californie, U.S.A.

179: Chippewa Indian motif. North America.
180: Indian motif. North America.
181: Finland, 17th century.
182: South Pacific.
183: Norway, 19th century.
184: Keyhole. France, 16th century.
185: Keyhole. France, 16th century.
186: Empire lyre motif. France.
187: Kwakiutl Indian motif. North-West Coast, North America.
188: Empire flambeau motif. France.
189: Finland, 19th century.
190: Panamint Indian motif. California, U.S.A.

179: Chippewa-Indianer, Nordamerika.
180: Indianisch, Nordamerika.
181: XVII. Jahrh., Finnland.
182: Ozeanien.
183: XIX. Jahrh., Norwegen.
184: Schlüsselloch-Umrahmung, XVI. Jahrh., Frankreich.
185: Schlüsselloch-Umrahmung, XVI. Jahrh., Frankreich.
186: Lyra, Empire, Frankreich.
187: Ornament-Motiv, Kwakiutl-Indianer, Nordwestküste, Nordamerika.
188: Fackel, Empire, Frankreich.
189: XIX. Jahrh., Finnland.
190: Panamint-Indianer, Kalifornien, USA.

179

180

181

182

183

184

185

186

187

188

189

190

191

192

193

191: Motif ornemental, IIIme siècle av. J.-C.-VIme siècle ap. J.-C., Equateur.
192: Motif ornemental, Haoussas, Afrique.
193: Motif ornemental, XIme-XVIme siècle, Equateur.
194: Motif ornemental, Afrique du Nord-Ouest.
195: Motif ornemental, Japon.
196: Tissu, époque précolombienne, Incas, Pérou.
197: Motif ornemental, Japon.
198: Motif ornemental, Japon.
199: Motif ornemental, Japon.
200: Motif ornemental, 3me millénaire av. J.-C., Malte.
201: Motif ornemental, Byzance.

194

195

191: Ecuador, 3rd century BC-6th century AD.
192: Hausa motif. West Africa.
193: Ecuador, 11th-16th centuries.
194: North-West Africa.
195: Japan.
196: Inca textile motif. Precolumbian Peru.
197: Japan.
198: Japan.
199: Japan.
200: Malta, 3rd millennium BC.
201: Byzantine motif.

196

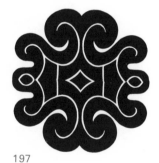

197

198

191: III. Jahrh. v. Chr. - VI. Jahrh. n. Chr., Ecuador.
192: Haussa, Afrika.
193: XI. - XVI. Jahrh., Ecuador.
194: Nordwest-Afrika.
195: Japan.
196: Gewebe, prä-kolumbianisch, Inka, Peru.
197: Japan.
198: Japan.
199: Japan.
200: 3. Jahrtausend v. Chr., Malta.
201: Byzanz.

199

200

201

191-201 **63**

202: Motif ornemental, Mayas, Yucatan, Mexique.
203: Motif ornemental, X^me-XI^me siècle, Mayas, Chichen Itza, Yucatan, Mexique.
204: Céramique, Chine.
205: Motif ornemental, XV^me siècle, art musulman, Shiraz, Iran.
206: Motif ornemental, art copte, Egypte.
207: Motif ornemental, XX^me siècle, Navajos, Arizona, U.S.A.
208: Motif ornemental, Inde.
209: Motif ornemental indien, Connecticut, U.S.A.

202: Maya motif. Yucatán, Precolumbian Mexico.
203: Maya motif. Chichén Itzá, Yucatán, Mexico, 10th-11th centuries.
204: Ceramic motif. China.
205: Islamic motif. Shiraz, Persia, 15th century.
206: Coptic motif. Egypt.
207: Navaho Indian motif. Arizona, U.S.A., 20th century.
208: India.
209: Indian motif. Connecticut, U.S.A.

202: Maya, Yukatan, Mexiko.
203: X. - XI. Jahrh., Maya, Chichen Itza, Yukatan, Mexiko.
204: Keramik, China.
205: XV. Jahrh., muselmanisch, Schiraz, Iran.
206: Koptisch, Ägypten.
207: XX. Jahrh., Navajos, Mexiko.
208: Indien.
209: Indianisches Ornament-Motiv, Connecticut, USA.

202

203

204

205

206

207

208

209

210

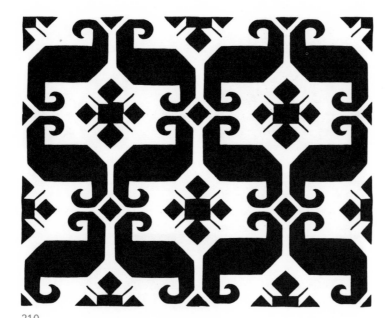

210

211

211

212

213

214

214

215: Motif ornemental, XIIIme siècle, Syrie.
216: Motif ornemental, Ethiopie.
217: Textile, XXme siècle, Danemark.
218: Caisson à rosace, Rome, Italie.
219: Motif ornemental, Japon.
220: Motif ornemental, XVIIIme siècle, Chine.
221: Motif ornemental, Japon.
222: Stuc, Mésopotamie.

215: Syria, 13th century.
216: Ethiopia.
217: Textile design. Denmark, 20th century.
218: Compartment of coffered ceiling with rosette. Rome, Italy.
219: Japan.
220: China, 18th century.
221: Japan.
222: Plasterwork motif. Mesopotamia.

215: XIII. Jahrh., Syrien.
216: Ëthopien.
217: Gewebe, XX. Jahrhundert, Dänemark.
218: Kassette mit Rosette, Rom, Italien.
219: Japan.
220: XVIII. Jahrh., China.
221: Japan.
222: Stuck, Mesopotamien.

215

216

216

217

218

219

220

220

221

222

222

223

223

224

224

225

226

226

227

228

228

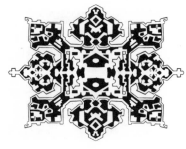

229

230 : Motif ornemental, époque Ts'ing, XVIII^{me} siècle, Chine.
231 : Motif ornemental, Afrique du Nord-Ouest.
232 : Mosaïque, Hongrie.
233 : Motif ornemental, archipel malais.
234 : Motif ornemental, archipel malais.
235 : Tressage, Ethiopie.
236 : Tissu, XVII^{me} siècle, Ulm, Allemagne.
237 : Motif ornemental Haoussas, Afrique.
238 : Tissu, XVI^{me} siècle, Italie.
239 : Tissu, art copte, Egypte.
240 : Motif ornemental, XVI^{me} siècle, Anatolie, Turquie.

230: *Ching period motif. China, 18th century.*
231: *North-west Africa.*
232: *Mosaic motif. Hungary.*
233: *Malay Archipelago.*
234: *Malay Archipelago.*
235: *Strapwork motif. Ethiopia.*
236: *Textile motif. Ulm, Germany, 17th century.*
237: *Hausa motif. West Africa.*
238: *Textile motif. Italy, 16th century.*
239: *Coptic textile motif. Egypt.*
240: *Turkey, 16th century.*

230: Tsing-Zeit, XVIII. Jahrh., China.
231: Nordwest-Afrika.
232: Mosaik, Ungarn.
233: Malaischer Archipel.
234: Malaischer Archipel.
235: Flechtwerk, Äthiopien.
236: Gewebe, XVII. Jahrh., Ulm, Deutschland.
237: Haussa, Afrika.
238: Gewebe, XVI. Jahrh., Italien.
239: Gewebe, koptisch, Ägypten.
240: XVI. Jahrh., Anatolien, Türkei.

230

231

232

232

233

234

235

236

237

238

239

240

240

241

242

243

244

245

246

247

248

249

250

251

**Motifs ornementaux
de structure ronde**

Rounded ornaments

Runde Ornament-Motive

252

253

254

255

256

257

258

259

260

261

262

252: Motif ornemental, Nouvel-Empire, Egypte.
253: Motif ornemental symbolique (dieu-soleil), Sumériens, Hittites, Chaldéens.
254: Disque solaire, Hittites, Asie Mineure.
255: Disque solaire, Cassides, Asie Mineure.
256: Sauvastika (croix gammée), Chine.
257: Roue de char, âge du fer, Chypre.
258: Motif ornemental symbolique («tomoye»), céramique, Japon.
259: Nœud, XIIme-IVme siècle av. J.-C., Pérou.
260: Motif ornemental, Japon.
261: Céramique, époque mycénienne, Chypre.
262: Motif ornemental, 2me millénaire av. J.-C., Palestine.

252: New Empire motif. Egypt.
253: Sumerian, Hittite and Chaldean symbol of sun god.
254: Hittite sun symbol. Asia Minor.
255: Casside sun symbol. Asia Minor.
256: Sauvastika. China.
257: Chariot wheel. Iron Age. Ancient Cyprus.
258: Symbolic ceramic motif (tomoye). Japan.
259: Knot motif. Peru, 12th-4th centuries BC.
260: Japan.
261: Mycenean period ceramic motif. Cyprus.
262: Palestine, 2nd millennium BC.

252: Neues Reich, Ägypten.
253: Symbolisches Ornament-Motiv (Sonnengott), Sumerer, Hethiter, Chaldäer.
254: Sonnenscheibe, Hethiter, Chaldäer.
255: Sonnenscheibe, Chassider, Kleinasien.
256: Sauvastika (Hakenkreuz), China.
257: Wagenrad, Eisenzeit, Zypern.
258: Symbolisches Ornament-Motiv («Tomoye»), Keramik, Japan.
259: Knoten, XII. - IV. Jahrh. v. Chr., Peru.
260: Japan.
261: Keramik, mykenisch, Zypern.
262: 2. Jahrtausend v. Chr., Palästina.

263: Motif ornemental, art arabe.
264: Motif ornemental, Japon.
265: Motif ornemental, XVIme siècle, Turquie.
266: Motif ornemental, Japon.
267: Motif ornemental, XXme siècle, U.S.A.
268: Tissu, art copte, Egypte.
269: Motif ornemental, art arabe.
270: Motif ornemental, art arabe.
271: Motif ornemental, art arabe.
272: Motif ornemental, art arabe.

263: Arab motif.
264: Japan.
265: Turkey, 16th century.
266: Japan.
267: U.S.A., 20th century.
268: Coptic textile design. Egypt.
269: Arab motif.
270: Arab motif.
271: Arab motif.
272: Arab motif.

263: Arabisch.
264: Japan.
265: XVI. Jahrh., Türkei.
266: Japan.
267: XX. Jahrh., USA.
268: Gewebe, koptisch, Ägypten.
269: Arabisch.
270: Arabisch.
271: Arabisch.
272: Arabisch.

263

263

264

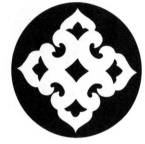

265

265

266

267

267

268

269

270

271

272

273

274

275

276

277

278

279

280

281

282

283

273: Croissant, XVIme siècle, Turquie.
274: Motif ornemental, Japon.
275: Motif ornemental, Turkestan chinois.
276: Motif ornemental, XVIIIme siècle, Pays-Bas.
277: Rosace, art roumî, Turquie.
278: Motif ornemental, Sibérie.
279: Tissu, art copte, Egypte.
280: Motif ornemental, XIXme siècle, Paraguay.
281: Motif ornemental, art roumî, Turquie.
282: Motif ornemental, Istanbul, Turquie.
283: Céramique, art minoen, Cnossos, Crète.

273: Crescent motif. Turkey, 16th century.
274: Japan.
275: Chinese Turkestan.
276: Netherlands, 18th century.
277: Roumi style rosette motif. Turkey.
278: Siberia.
279: Coptic textile motif. Egypt.
280: Paraguay, 19th century.
281: Roumi style motif. Turkey.
282: Istanbul, Turkey.
283: Minoan ceramic design. Cnossos, Crete.

273: Halbmond, XVI. Jahrh., Türkei.
274: Japan.
275: Chinesisch-Turkestan.
276: XVIII. Jahrh., Holland.
277: Rosette, Rumi, Türkei.
278: Sibirien.
279: Gewebe, koptisch, Ägypten.
280: XIX. Jahrh., Paraguay.
281: Rumi, Türkei.
282: Istanbul, Türkei.
283: Keramik, minoisch, Knossos, Kreta.

284: Motif ornemental, 5me millénaire av. J.-C., Halaf, Mésopotamie.
285: Motif ornemental, Océanie.
286: Motif ornemental, Congo.
287: Céramique, Indiens Pueblos, Nouveau-Mexique, U.S.A.
288: Motif ornemental, 5me millénaire av. J.-C., Mésopotamie.
289: Motif ornemental, civilisation de l'Indus, 3me millénaire av. J.-C.
290: Motif ornemental, Indiens Pomos, Californie, U.S.A.
291: Motif ornemental, XXme siècle, Indiens Hopis, Arizona, U.S.A.
292: Motif ornemental, Ruanda.
293: Céramique, Indiens Pueblos, Nouveau-Mexique, U.S.A.
294: Motif ornemental, Oubangui, Afrique.
295: Céramique, Indiens Pueblos, Nouveau-Mexique, U.S.A.

284: Halaf, Mesopotamia, 5th millennium BC.
285: South Pacific.
286: Congo.
287: Pueblo Indian ceramic motif. New Mexico, U.S.A.
288: Mesopotamia, 5th millennium BC.
289: Indus Civilization motif. 3rd millennium BC.
290: Pomo Indian motif. California, U.S.A.
291: Hopi Indian motif. Arizona, U.S.A., 20th century.
292: Rwanda, Central Africa.
293: Pueblo Indian ceramic motif. New Mexico, U.S.A.
294: Ubangi, Central Africa.
295: Pueblo Indian ceramic motif. New Mexico, U.S.A.

284: 5. Jahrtausend v. Chr., Halaf, Mesopotamien.
285: Ozeanien.
286: Kongo.
287: Keramik, Pueblo-Indianer, Neu-Mexiko, USA.
288: 5. Jahrtausend v. Chr., Mesopotamien.
289: Indus-Kultur, 3. Jahrtausend v. Chr.
290: Pomo-Indianer, Kalifornien, USA.
291: XX. Jahrh., Hopi-Indianer, Arizona, USA.
292: Ruanda.
293: Keramik, Pueblo-Indianer, Neu-Mexiko, USA.
294: Ubangi, Afrika.
295: Keramik, Pueblo-Indianer, Neu-Mexiko, USA.

284

285

286

287

288

289

290

291

292

293

294

295

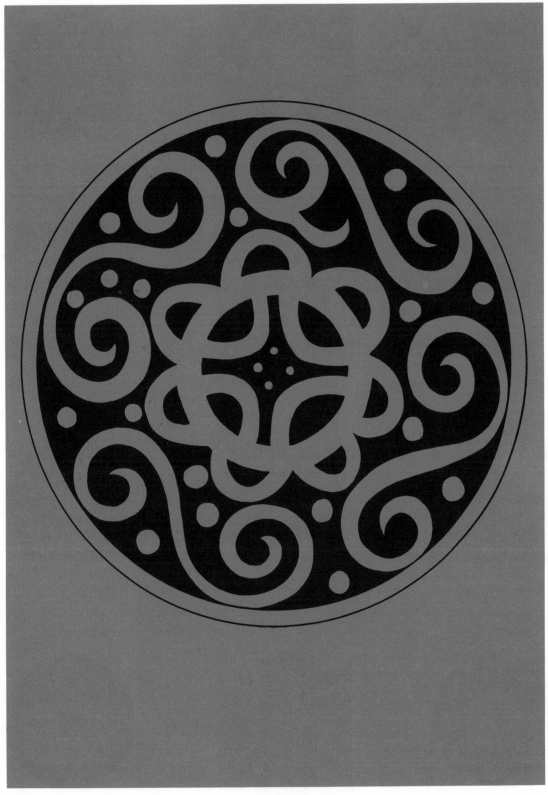

296: Céramique, Chine.

296: Ceramic motif. China.

296: Keramik, China.

297

297

298

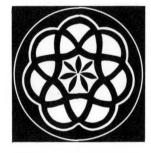
299

299

300

301

302

303

304

305

306

307

307

307: Mosaïque, art romain, Italie.
308: Motif ornemental, 18me dynastie, Egypte.

307: Roman mosaic motif. Italy.
308: XVIIIth Dynasty motif. Egypt, 16th-14th centuries BC.

307: Mosaik, römisch, Italien.
308: 18. Dynastie, Ägypten.

308

308

309: Mosaïque, art romain, Nîmes, France.
310: Bois taillé, Turquie.

309: Roman mosaic motif. Nîmes, France.
310: Woodcarving motif. Turkey.

309: Mosaik, römisch, Nîmes, Frankreich.
310: Holzschnitt, Türkei.

309

309

310

310

311

311: Motif ornemental, Inde.
312: Motif ornemental, XVII^{me} siècle, Espagne.

311: India.
312: Spain, 17th century.

311: Indien.
312: XVII. Jahrh., Spanien.

311

312

312

313 : Motif ornemental, palais de Nimroud, Méso-
potamie.
314 : Mosaïque, art romain, Nîmes, France.

313: Palace, Nimrud, Mesopotamia.
314: Roman mosaic motif. Nîmes, France.

313 : Palast von Nimrud, Mesopotamien.
314 : Mosaik, römisch, Nîmes, Frankreich.

313

313

314

314

315

315

315: Motif ornemental, art roman.
316: Motif ornemental, Océanie.
317: Motif ornemental, art mycénien, Grèce.
318: Céramique, Chine.
319: Motif ornemental, île Haï-nan, golfe du Tonkin.
320: Tapis, Chine.

315: Romanesque motif.
316: South Pacific.
317: Mycenean motif. Greece.
318: Ceramic motif. China.
319: Hainan Island, Gulf of Tonkin.
320: Carpet motif. China.

315: Romanisch.
316: Ozeanien.
317: Mykenisch, Griechenland.
318: Keramik, China.
319: Insel Hainan, Golf von Tonking.
320: Teppich, China.

316

317

317

318

319

320

315-320 **83**

321 : Motif ornemental, Inde.
322 : Motif ornemental, Empire, France.
323 : Motif ornemental, Asie Mineure.
324 : Motif ornemental, époque T'ang, IX^me siècle, Chine.
325 : Motif ornemental, art musulman, XIII^me siècle, Iran.
326 : Motif ornemental, XVII^me siècle, Japon.
327 : Motif ornemental, 1^er millénaire av. J.-C., Nimroud, Mésopotamie.

321 : India.
322 : Empire motif. France.
323 : Asia Minor.
324 : T'ang period motif. China, 9th century.
325 : Islamic motif. Persia, 13th century.
326 : Japan, 17th century.
327 : Nimrud, Mesopotamia, 1st millennium BC.

321 : Indien.
322 : Empire, Frankreich.
323 : Kleinasien.
324 : Tang-Zeit, IX. Jahrh., China.
325 : Muselmanisch, XIII. Jahrh., Iran.
326 : XVIII. Jahrh., Japan.
327 : 1. Jahrtausend v. Chr., Nimrud, Mesopotamien.

321

321

322

323

324

325

326

327

328

329

330

328: Céramique, Haoussas, Afrique.
329: Mosaïque, art gréco-romain, Ostie, Italie.
330: Motif ornemental, 4me millénaire av. J.-C., Eridou, Mésopotamie.
331: Clé, XVIIIme siècle, Turquie.
332: Cuivre, Xme siècle, Ohio, U.S.A.
333: Motif ornemental, art mycénien, Tirynthe. Grèce.
334: Motif ornemental, XVIIIme siècle, Norvège.

328: Hausa ceramic motif. West Africa.
329: Graeco-Roman mosaic motif. Ostia, Italy.
330: Eridu, Mesopotamia, 4th millennium BC.
331: Key. Turkey, 18th century.
332: Copperwork motif. Ohio, U.S.A., 10th century.
333: Mycenean motif. Tiryns, Greece.
334: Norway, 18th century.

328: Keramik, Haussa, Afrika.
329: Mosaik, griechisch-römisch, Ostia, Italien.
330: 4. Jahrtausend v. Chr., Eridu, Mesopotamien.
331: Schlüssel, XVIII. Jahrh., Türkei.
332: Kupfer, X. Jahrh., Ohio, USA.
333: Mykenisch, Tiryns, Griechenland.
334: XVIII. Jahrh., Norwegen.

331

332

333

334

335: Céramique, XX^{me} siècle, Italie.
336: Collier, perles, XX^{me} siècle, Pérou.

335: Ceramic motif. Italy, 20th century.
336: Bead necklace. Peru, 20th century.

335: Kachel, XX. Jahrh.
336: Perlenhalsband, XX. Jahrh., Peru.

335

335

336

336

337

338

339

340

341

342

343

344

345

346

347

348

349 : Motif ornemental, Chine.
350 : Motif ornemental, Angola.
351 : Motif ornemental, archipel malais.
352 : Céramique, bassin du Zambèze, Afrique.

349: China.
350: Angola.
351: Malay Archipelago.
352: Ceramic motif. Zambezi basin, Central Africa.

349: China.
350: Angola.
351: Malaischer Archipel.
352: Keramik, Sambesi, Afrika.

349

349

350

351

352

353

354

355

355

356

356

353: Motif ornemental, art copte, Vme-VIme siècle, Egypte.
354: Mosaïque, Villa de Tossa, Gerone, Espagne.
355: Motif ornemental, XIXme siècle, Pologne.
356: Motif ornemental, VIIme siècle av. J.-C., Egypte.

353: Coptic motif. Egypt, 5th-6th centuries.
354: Mosaic motif. Villa de Tossa, Gerona, Spain.
355: Poland, 19th century.
356: Egypt, 7th century BC.

353: Koptisch, V. - VI. Jahrh., Ägypten.
354: Mosaik, Villa de Tossa, Gerona, Spanien.
355: XIX. Jahrh., Polen.
356: VII. Jahrh. v. Chr., Ägypten.

357: Motif ornemental, Chine.
358: Rosace, temple de Sanchi, Inde.
359: Motif ornemental, 2me millénaire av. J.-C. Andalousie, Espagne.
360: Encadrement de serrure, XVIme siècle, France.
361: Trident de Siva, XVIme-XVIIme siècle, Inde du Sud.
362: Motif ornemental, art roumî, Turquie.
363: Motif ornemental, île de l'Amirauté, Océanie.
364: Motif ornemental, Nouvelle-Guinée.
365: Tissu, XVIme siècle, Italie.
366: Motif ornemental, île de Timor, archipel malais.
367: Tissu, XVIme siècle, Italie.

357: China.
358: Rosette motif. Temple of Sanchi, India.
359: Andalucía, Spain, 2nd millennium BC.
360: Keyhole. France, 16th century.
361: Shiva's trident. Southern India, 16th-17th centuries.
362: Roumi style motif. Turkey.
363: Admiralty Island, South Pacific.
364: New Guinea.
365: Textile motif. Italy, 16th century.
366: Timor Island, Malay Archipelago.
367: Textile motif. Italy, 16th century.

357: China.
358: Rosette, Tempel von Sanchi, Indien.
359: 2. Jahrtausend v. Chr., Andalusien, Spanien.
360: Schlüsselloch-Umrahmung, XVI. Jahrh., Frankreich.
361: Dreizack des Schiwa, XVI. - XVII. Jahrh., Süd-Indien.
362: Rumi, Türkei.
363: Admiralitätsinsel, Ozeanien.
364: Neu-Guinea.
365: Gewebe, XVI. Jahrh., Italien.
366: Timor-Insel, Malaischer Archipel.
367: Gewebe, XVI. Jahrh., Italien.

357

358

359

360

361

361

362

363

364

365

366

367

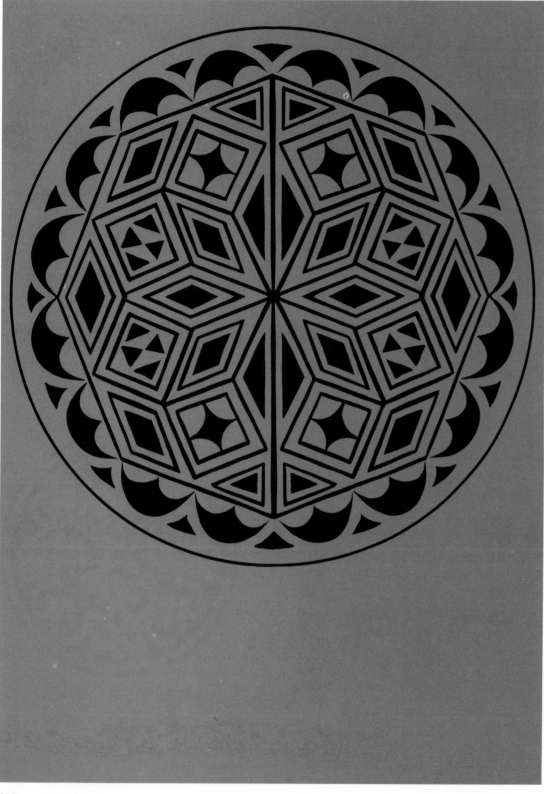

368

368: Mosaïque, art romain, Wiltingen, Allemagne.

368: Roman mosaic motif. Wiltingen, Germany.

368: Mosaik, römisch, Wiltingen, Deutschland.

369: Lauriers et palmettes, Empire, France.
370: Motif ornemental, IIIᵐᵉ-IVᵐᵉ siècle, Alexan-
drie, Egypte.
371: Motif ornemental, Empire, France.
372: Motif ornemental, Xᵐᵉ siècle, Samarcande,
U.R.S.S.

369: Empire laurel and palmette motif. France.
370: Alexandria, Egypt, 3rd-4th centuries.
371: Empire motif. France.
372: Samarkand, U.S.S.R., 10th century.

369: Lorbeer und Palmette, Empire, Frankreich.
370: III. - IV. Jahrh., Alexandrien, Ägypten.
371: Empire, Frankreich.
372: X. Jahrh., Samarkand, UdSSR.

369

370

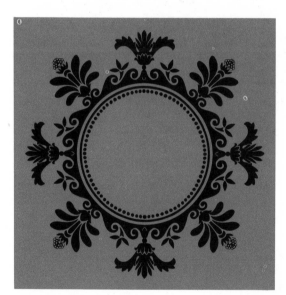

371

372

373

374

375

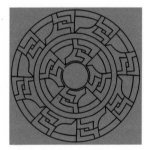

376

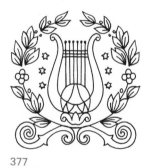

377

378

373: Gravure sur bois, XVII^me siècle, France.
374: Vignette typographique (Deberny et Peignot), début du XX^me siècle, Paris, France.
375: Vignette typographique (Deberny et Peignot), début du XX^me siècle, Paris, France.
376: Couronnes, Empire, France.
377: Motif ornemental, Empire, France.
378: Motif ornemental, IV^me-V^me siècle, Japon.

373: Ornamental border, woodcut. France, 17th century.
374: Type ornament, cast by Deberny and Peignot. Paris, France, beginning of 20th century.
375: Type ornament, cast by Deberny and Peignot. Paris, France, beginning of 20th century.
376: Empire wreath motif. France.
377: Empire motif, France.
378: Geometrical motif. Japan, 4th-5th centuries.

373: Holzschnitt, XVII. Jahrh., Frankreich.
374: Typographische Vignette (Deberny und Peignot), Anfang des XX. Jahrh., Paris, Frankreich.
375: Typographische Vignette (Deberny und Peignot), Anfang des XX. Jahrh., Paris, Frankreich.
376: Krone, Empire, Frankreich.
377: Empire, Frankreich.
378: IV. - V. Jahrh., Japan.

**Motifs ornementaux
de structure triangulaire**

Triangular ornaments

Dreieckige Ornament-Motive

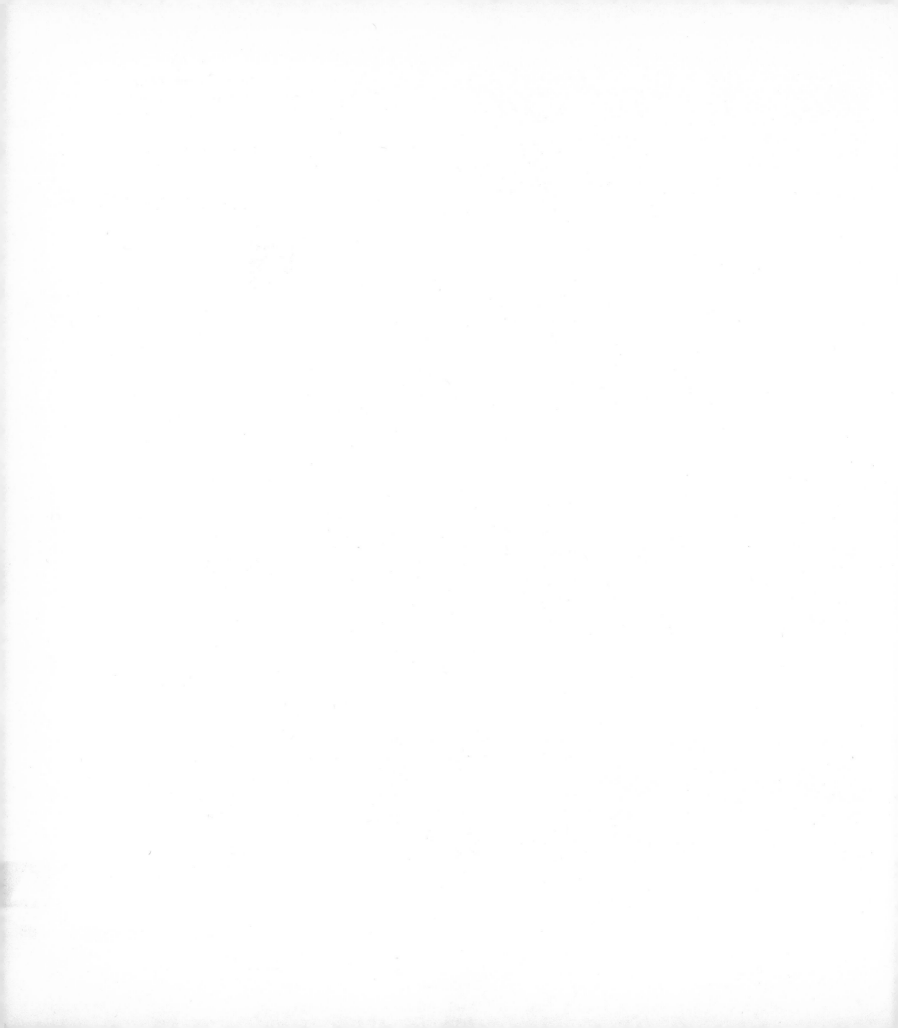

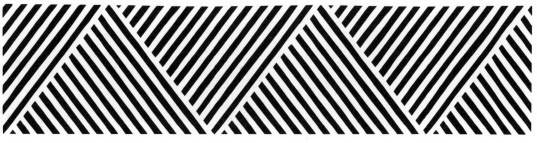

379

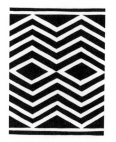

380

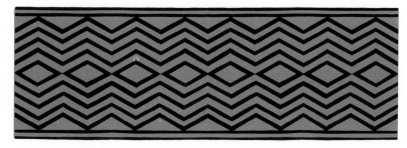

380

381

381

382

382

383 : Motif ornemental, 4me millénaire av J.-C.,
civilisation Negadah, Egypte.
384 : Motif ornemental, art cycladique, VIIme
siècle av J.-C., Egine, Grèce.
385 : Céramique, Phénicie.
386 : Motif ornemental, îles Tonga, Polynésie.

*383: Negadah culture motif. Egypt, 4th millen-
nium BC.*
*384: Cycladic motif. Aegina, Greece, 7th cen-
tury BC.*
385: Ceramic motif. Phoenicia.
386: Tonga Islands, Polynesia.

383 : 4. Jahrtausend v. Chr., Negade-Kultur,
Ägypten.
384 : Kykladisch, VII. Jahrh. v. Chr., Ägina,
Griechenland.
385 : Keramik, phönizisch.
386 : Ornament-Motiv, Tonga-Inseln, Polynesien.

383

383

384

385

385

386

387

388

389

390

387: Motif ornemental, Nouvelle-Guinée.
388: Motif ornemental, époque précolombienne,
Incas, Pérou.
389: Motif ornemental, Bakubas, Congo.
390: Motif ornemental, Bakubas, Congo.

387: New Guinea.
388: Inca motif. Precolumbian Peru.
389: Bakuba motif. Congo.
390: Bakuba motif. Congo.

387: Neu-Guinea.
388: Prä-kolumbianisch, Inka, Peru.
389: Bakuba, Kongo.
390: Bakuba, Kongo.

391: Motif ornemental, Teotihuacan, Mexique.
392: Motif ornemental, XVI^me siècle, Turquie.
393: Motif ornemental, Amérique du Sud.
394: Motif ornemental, XI^me-XII^me siècle, Equa-
teur.

391: Teotihuacán, Precolumbian Mexico.
392: Turkey, 16th century.
393: South America.
394: Ecuador, 11th-12th centuries.

391: Teotihuacán, Mexiko.
392: XVI. Jahrh., Türkei.
393: Südamerika.
394: XI. - XII. Jahrh., Ecuador.

391

392 392

393

394 394

395

395: Motif ornemental, île de Haï-nan, golfe du Tonkin.
396: Tissu, XXᵐᵉ siècle, Bulgarie.
397: Motif ornemental, XIXᵐᵉ siècle, Roumanie.
398: Tissu, province Yunnan, Chine.

395: Hainan Island, Gulf of Tonkin.
396: Textile motif. Bulgaria, 20th century.
397: Romania, 19th century.
398: Textile motif. Yunnan province, China.

395: Insel Hainan, Golf von Tonking.
396: Gewebe, XX. Jahrh., Bulgarien.
397: XIX. Jahrh., Rumänien.
398: Gewebe, Provinz Yunnan, China.

396

397

398

399: Motif ornemental, île de Haï-nan, golfe du Tonkin.
400: Motif ornemental, île de Haï-nan, golfe du Tonkin.
401: Tissu, époque précolombienne, Incas, Pérou.
402: Motif ornemental, XIme-XVIme siècle, Brésil.

399: Hainan Island, Gulf of Tonkin.
400: Hainan Island, Gulf of Tonkin.
401: Inca textile motif. Precolumbian Peru.
402: Brazil, 11th-16th centuries.

399: Insel Hainan, Golf von Tonking.
400: Insel Hainan, Golf von Tonking.
401: Gewebe, prä-kolumbianisch, Inka, Peru.
402: XI. - XVI. Jahrh., Brasilien.

399

400

401

402

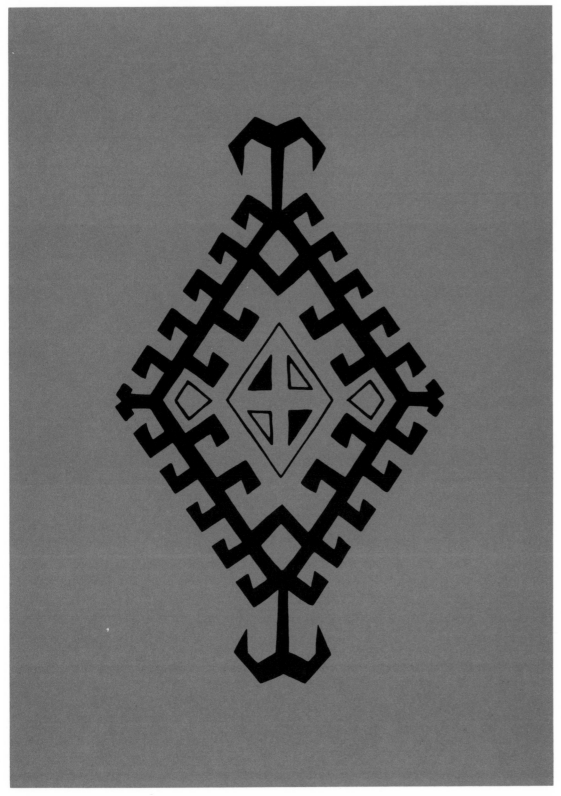

403: Tapis (patte de dragon), Turquie.

403: Dragon-foot carpet motif. Turkey.

403: Teppich (Drachentatze), Türkei.

403

404: Motif ornemental indien, Oklahoma, U.S.A.
405: Motif ornemental, époque précolombienne, Incas, Pérou.
406: Motif ornemental, époque précolombienne, Incas, Pérou.

404: Indian motif. Oklahoma, U.S.A.
405: Inca motif. Precolumbian Peru.
406: Inca motif. Precolumbian Peru.

404: Indianisch, Oklahoma, USA.
405: Prä-kolumbianisch, Inka, Peru.
406: Prä-kolumbianisch, Inka, Peru.

404

405

406

407

408

409

410

407: Motif ornemental, art arabe.
408: Motif ornemental, XVme-XVIme siècle, Chili.
409: Motif ornemental, XIXme siècle, Roumanie.
410: Motif ornemental, XVme siècle, mosquée d'Edirné, Turquie.

407: Arab motif.
408: Chile, 15th-16th centuries.
409: Romania, 19th century.
410: Mosque, Edirne, Turkey, 15th century.

407: Arabisch.
408: XV. - XVI. Jahrh., Chile.
409: XIX. Jahrh., Rumänien.
410: XV. Jahrh., Moschee von Edirne, Türkei.

411: Motif ornemental, Bornéo.
412: Sauvastika, Turquie.
413: Motif architectural, époque précolombienne, Mexique.
414: Perles, Indiens Dakotas, Amérique du Nord.
415: Motif ornemental, époque précolombienne, Pérou.
416: Motif ornemental, époque néolithique, Thessalie, Grèce.
417: Motif ornemental, Nigeria.
418: Tissu, XXᵐᵉ siècle, Bulgarie.

411: Geometrical motif. Borneo.
412: Sauvastika motif. Turkey.
413: Stonework motif. Precolumbian Mexico.
414: Dakota Indian beadwork motif. North America.
415: Precolumbian Peru.
416: Geometrical motif. Thessaly, Greece, New Stone Age.
417: Nigeria.
418: Textile motif. Bulgaria, 20th century.

411: Borneo.
412: Sauvastika, Türkei.
413: Architektonisches Motiv, Mexiko.
414: Perlen, Dakota-Indianer, Nordamerika.
415: Prä-kolumbianisch, Peru.
416: Jüngere Steinzeit, Thessalien, Griechenland.
417: Nigeria.
418: Gewebe, XX. Jahrh., Bulgarien.

411

411

412

413

414

415

416

417

418

419

420

421

419: Motif ornemental, Indiens des Grandes Plaines, U.S.A.
420: Motif ornemental, Incas, Pérou.
421: Motif ornemental, VIme-Xme siècle, Byzance.
422: Motif ornemental, XXme siècle, Pérou.
423: Motif ornemental, Mesa Verde, Colorado, U.S.A.
424: Motif ornemental, époque précolombienne, Incas, Pérou.

419: Plains Indian motif. U.S.A.
420: Inca motif. Precolumbian Peru.
421: Byzantine motif. 6th-10th centuries.
422: Peru, 20th century.
423: Mesa Verde, Colorado, U.S.A.
424: Inca motif. Precolumbian Peru.

422

423

419: Prärieindianer, USA.
420: Inka, Peru.
421: VI. - X. Jahrh., Byzanz.
422: XX. Jahrh., Peru.
423: Mesa Verde, Colorado, USA.
424: Prä-kolumbianisch, Inka, Peru.

424

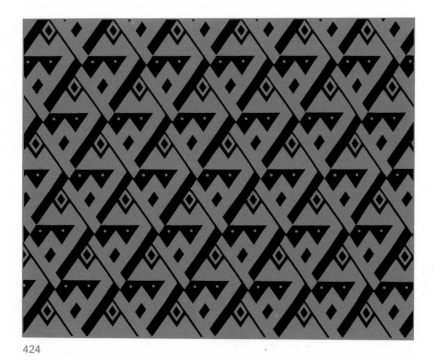

424

425: Motif ornemental, époque 1900, France.
426: Motif ornemental, époque 1900, France.
427: Gravure sur bois, XVIIᵐᵉ siècle, France.
428: Motif ornemental, presqu'île de Malacca, Malaisie.
429: Motif ornemental, Pamir, Asie centrale.
430: Motif ornemental, U.R.S.S.
431: Motif ornemental, XIXᵐᵉ siècle, Norvège.
432: Broderie, Chine.

425: France, end of 19th century.
426: France, end of 19th century.
427: Woodcut motif. France, 17th century.
428: Malacca Peninsula, Malaysia.
429: Pamir, Central Asia.
430: U.S.S.R.
431: Norway, 19th century.
432: Embroidered motif. China.

425: Um 1900, Frankreich.
426: Um 1900, Frankreich.
427: Holzschnitt, XVII. Jahrh., Frankreich.
428: Halbinsel von Malakka, Malaischer Archipel.
429: Pamir, Zentralasien.
430: UdSSR.
431: XIX. Jahrh., Norwegen.
432: Stickerei, China.

425

426

427

428

429

429

430

431

432

433

434

435

436

437

438

439

440

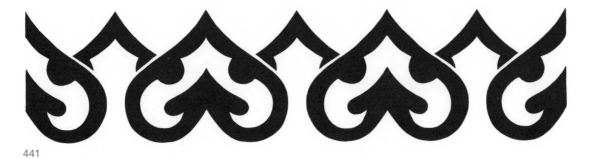

441

**Motifs ornementaux
en continu**

Continuous ornaments

**Fortlaufende Ornament-
Motive**

442

442: Tresse, Empire, France.
443: Tresse, IXᵐᵉ siècle av. J.-C., Nimroud, Mésopotamie.
444: Tresse, art roman, France.
445: Tressage, Nigéria.
446: Tresse, XIIᵐᵉ siècle, Egypte.

442: Empire strapwork motif. France.
443: Strapwork motif. Nimrud, Mesopotamia, 9th century BC.
444: Romanesque strapwork motif. France.
445: Strapwork motif. Nigeria.
446: Strapwork motif. Egypt, 12th century.

442: Flechtwerk, Empire, Frankreich.
443: Flechtwerk, IX. Jahrh. v. Chr., Nimrud, Mesopotamien.
444: Flechtwerk, romanisch, Frankreich.
445: Flechtwerk, Nigeria.
446: Flechtwerk, XII. Jahrh., Ägypten.

443

444

445

446

447: Tresse, mosaïque, Gérone, Espagne.
448: Nœud symbolique, laque, Chine.
449: Serpents entrelacés, Tchankri, Asie Mineure.
450: Nœud végétal, XVᵐᵉ siècle, Italie.
451: Nœud mystique, XVIIIᵐᵉ siècle, Chine.
452: Nœud mystique, XVIIIᵐᵉ siècle, Chine.

447: *Mosaic strapwork motif, Gerona, Spain.*
448: *Symbolic knot motif, lacquerwork. China.*
449: *Intertwined snake motif. Chankri, Asia Minor.*
450: *Frond-knot motif. Italy, 15th century.*
451: *Mystic knot motif. China, 18th century.*
452: *Mystic knot motif. China, 18th century.*

447: Geflecht, Mosaik, Gerona, Spanien.
448: Symbolischer Knoten, Lackarbeit, China.
449: Verschlungene Schlangen, Tschangri, Kleinasien.
450: Pflanzenknoten, XV. Jahrh., Italien.
451: Mystischer Knoten, XVIII. Jahrh., China.
452: Mystischer Knoten, XVIII. Jahrh., China.

447

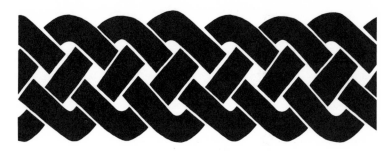

447

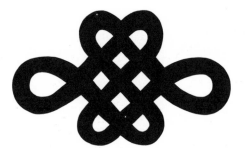

448

448

449

449

450

451

452

453
453
454

455

456

457

458: Torsade, art hittite, IXᵐᵉ siècle av. J.-C.,
 Asie Mineure.
459: Torsade, Luristan, Iran.
460: Tapisserie, art copte, Egypte.

458: Hittite torc motif. Asia Minor, 9th century
BC.
459: Torc motif. Luristan, Persia.
460: Coptic tapestry motif. Egypt.

458: Kordel, hethitisch, IX. Jahrh. v. Chr., Klein-
 asien.
459: Kordel, Luristan, Iran.
460: Tapisserie, koptisch, Ägypten.

458 458

459

460

460

461

461

462

463

463

464

465: Motif ornemental, art roman, France.
466: Motif ornemental, XV^{me} siècle, Séville, Espagne.

465: Romanesque motif. France.
466: Seville, Spain, 15th century.

465: Romanisch, Frankreich.
466: XV. Jahrh., Sevilla, Spanien.

465

465

466

466

467

467: Nœud symbolique hindou, Inde.

467: Symbolic knot motif. India.

467: Symbolischer Hindu-Knoten, Indien.

468: Nœud de Salomon, Tunisie.
469: Motif ornemental, XIIIᵐᵉ siècle av. J.-C., Iran.
470: Motif ornemental, Indiens Hopis, U.S.A.
471: Nœud de Salomon, Tunisie.
472: Nœud, Congo.
473: Nœud, Nigeria.
474: Nœud, Cameroun.
475: Motif ornemental, XVIIIᵐᵉ siècle, Danemark.
476: Encadrement XVIᵐᵉ siècle, Lyon, France.

468: Salomonic knot motif. Tunisia.
469: Persia, 13th century BC.
470: Hopi Indian motif. Arizona, U.S.A.
471: Salomonic knot motif. Tunisia.
472: Knot motif. Congo.
473: Knot motif. Nigeria.
474: Knot motif. Cameroon.
475: Denmark, 18th century.
476: Printer's border motif. Lyons, France, 16th century.

468: Knoten des Salomon, Tunesien.
469: XIII. Jahrh. v. Chr., Iran.
470: Hopi-Indianer, Nordamerika.
471: Knoten des Salomon, Tunesien.
472: Knoten, Kongo.
473: Knoten, Nigeria.
474: Knoten, Kamerun.
475: XVIII. Jahrh., Dänemark.
476: Einrahmung, XVI. Jahrh., Lyon, Frankreich.

468

469

470

471

472

472

473

473

474

475

476

477

478

479

477: Nœud de Salomon, Tunisie.
478: Manuscrit, art copte, VII^me siècle, Egypte.
479: Motif ornemental, Japon.
480: Motif ornemental, XII^me siècle, Byzance.
481: Motif ornemental, gravure, XVI^me siècle, Lyon, France.
482: Motif ornemental, Assam, Inde.
483: Motif ornemental, Ethiopie.

477: Salomonic knot motif. Tunisia.
478: Coptic motif from manuscript. Egypt, 7th century.
479: Japan.
480: Byzantine motif, 12th century.
481: Engraved motif, Lyons, France, 16th century.
482: Assam, India.
483: Ethiopia.

477: Knoten des Salomon, Tunesien.
478: Handschrift, koptisch, VII. Jahrh., Ägypten.
479: Japan.
480: XII. Jahrh., Byzanz.
481: Stich, XVI. Jahrh., Lyon, Frankreich.
482: Assam, Indien.
483: Äthiopien.

480

480

481

482



483

484 : Tissu, époque des Pharaons, Egypte.
485 : Céramique, Indiens Pueblos, Nouveau-
Mexique, U.S.A.
486 : Motif ornemental, Congo.
487 : Motif ornemental, Congo.
488 : Motif ornemental, Côte-d'Ivoire.

484: Textile motif. Ancient Egypt.
485: Pueblo Indian ceramic motif. New Mexico,
U.S.A.
486: Congo.
487: Congo.
488: Ivory Coast.

484 : Pharaonen-Zeit, Ägypten.
485 : Keramik, Pueblo-Indianer, Neu-Mexiko,
USA.
486 : Kongo.
487 : Kongo.
488 : Elfenbeinküste.

484

484

485

486

487

488

489

489

489: Frise, palais de Nimroud, Mésopotamie.
490: Motif ornemental, X^me-XI^me siècle, Egypte.
491: Motif ornemental, Ethiopie.

489: Frieze motif. Palace, Nimrud, Mesopotamia.
490: Egypt, 10th-11th centuries.
491: Ethiopia.

489: Fries, Palast von Nimrud, Mesopotamien.
490: X. - XI. Jahrh., Ägypten.
491: Äthiopien.

490

490

491

492: Tissu, époque des Pharaons, Egypte.
493: Motif ornemental, Congo.
494: Motif ornemental, Cameroun.
495: Motif ornemental, Congo.
496: Motif ornemental, Bakubas, Congo.

492: *Textile motif. Ancient Egypt.*
493: *Congo.*
494: *Cameroon.*
495: *Congo.*
496: *Bakuba motif. Congo.*

492: Gewebe, Pharaonen-Zeit, Ägypten.
493: Kongo.
494: Kamerun.
495: Kongo.
496: Bakuba, Kongo.

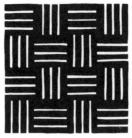

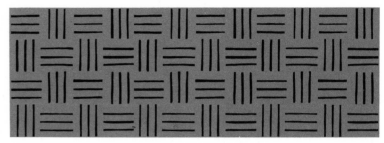

492

492

493

493

494

495

496

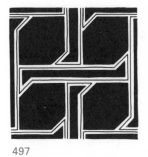

497

497

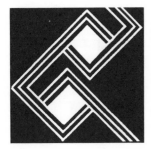

498

498

497: Motif ornemental, XVI^me siècle, Italie.
498: Motif ornemental, Congo.

497: Italy, 16th century.
498: Congo.

497: XVI. Jahrh., Italien.
498: Kongo.

499: Motif ornemental, VIᵐᵉ siècle, Venezuela.
500: Profil de pneu.
501: Mosaïque, Pompéi, Italie.

499: Venezuela, 6th century.
500: Tyre tread.
501: Roman mosaic motif. Pompeii, Italy.

499: VI. Jahrh., Venezuela.
500: Profil eines Autoreifens.
501: Mosaik, Pompeji, Italien.

499

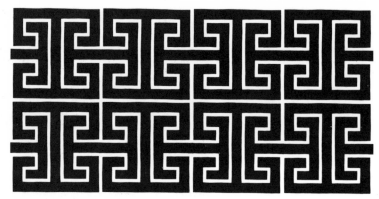

499

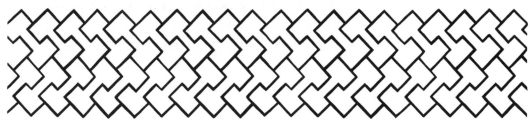

500

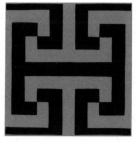

501

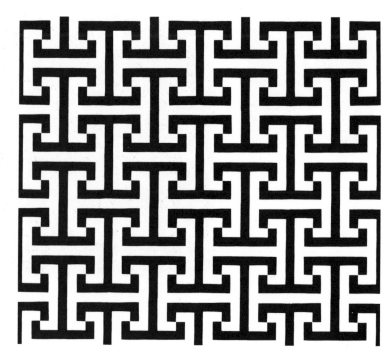

501

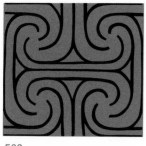

502

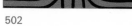

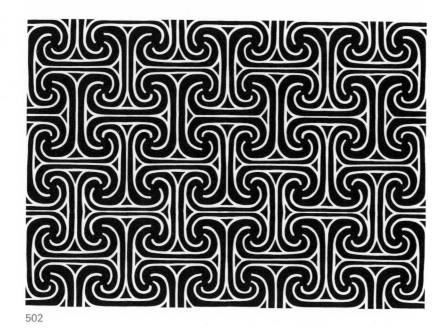

502

502: Motif ornemental, Hittites, Asie Mineure.
503: Plafond, époque des Pharaons, Egypte.

502: Hittite motif. Asia Minor.
503: Ceiling motif. Ancient Egypt.

502: Hethitisch, Kleinasien.
503: Plafond, Pharaonen-Zeit, Ägypten.

503

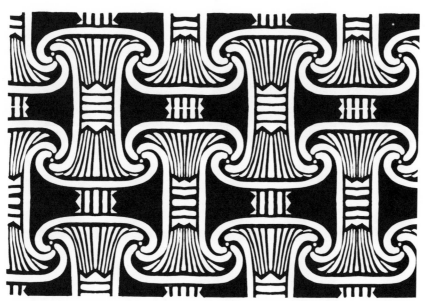

503

504: Motif ornemental, île de Haï-nan, golfe du Tonkin.
505: Mosaïque, époque des Ptolémées, Pergame, Asie Mineure.
506: Motif ornemental, Ghana.
507: Motif ornemental, Kirghizistan, U.R.S.S.

504: Hainan Island, Gulf of Tonkin.
505: Ptolemaic period mosaic motif. Pergamum, Asia Minor.
506: Ghana.
507: Kirghizia, U.S.S.R.

504: Insel Hainan, Golf von Tonking.
505: Mosaik, Ptolemäer-Zeit, Pergamon, Kleinasien.
506: Ghana.
507: Kirghisistan, UdSSR.

504

505

506

507

508

508

508: Motif ornemental, Ghana.
509: Motif ornemental, époque précolombienne, Colombie.
510: Plat, métal, XVIᵐᵉ siècle, Turquie.

508: Ghana.
509: Precolumbian Colombia.
510: Metal dish. Turkey, 16th century.

508: Ghana.
509: Prä-kolumbianisch, Kolumbien.
510: Platte, Metall, XVI. Jahrh., Türkei.

509

509

510

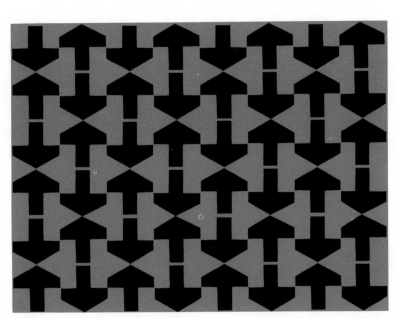

510

511: Motif ornemental, Nouvel Empire, Egypte.
512: Mosaïque, Vᵐᵉ siècle, Ravenne, Italie.
513: Mosaïque, Pompéi, Italie.
514: Céramique, Indiens Pueblos, Nouveau-
Mexique, U.S.A.

511: New Empire period motif. Ancient Egypt.
512: Mosaic motif. Ravenna, Italy, 5th century.
513: Roman mosaic motif. Pompeii, Italy.
514: Pueblo Indian ceramic motif. New Mexico,
U.S.A.

511: Neues Reich, Ägypten.
512: Mosaik, V. Jahrh., Ravenna, Italien.
513: Mosaik, Pompeji, Italien.
514: Keramik, Pueblo-Indianer, Neu-Mexiko,
USA.

511

511

512

512

513

514

515

516

517

518

519: Motif ornemental, Kirghizistan, U.R.S.S.
520: Tissu, XVIᵐᵉ siècle, Italie.
521: Poterie, Houpei, Chine.
522: Motif ornemental, époque Azuka, VIᵐᵉ-
VIIᵐᵉ siècle, Japon.

519: Kirghizia, U.S.S.R.
520: Textile motif. Italy, 16th century.
521: Ceramic motif. Hupei, China.
522: Azuka period motif. Japan, 6th-7th centuries.

519: Kirghisistan, UdSSR.
520: Gewebe, XVI. Jahrh., Italien.
521: Töpferei, Hupei, China.
522: Azuka, VI. - VII. Jahrh., Japan.

519

520

520

521

522

523

524

525

526

526

527 : Motif ornemental, Maoris, Nouvelle-Zélande.
528 : Motif ornemental, époque précolombienne, Incas, Pérou.
529 : Montagnes, XVᵐᵉ siècle, école Jaïne, Inde.
530 : Motif ornemental, époque Ming, XIVᵐᵉ-XVIᵐᵉ siècle, Chine.

527: Maori motif. New Zealand.
528: Inca motif. Precolumbian Peru.
529: Jaina style mountain motif. India, 15th century.
530: Ming period motif. China, 14th-16th centuries.

527 : Maori, Neuseeland.
528 : Prä-kolumbianisch, Inka, Peru.
529 : Berge, XV. Jahrh., Jaina-Schule, Indien.
530 : Ming-Zeit, XIV. - XVI. Jahrh., China.

527

528

529

530

531

531

532

533

534

535: Motif ornemental, XIXᵐᵉ siècle, U.R.S.S.
536: Motif ornemental, Egine, Grèce.
537: Motif ornemental, VIIIᵐᵉ-XIᵐᵉ siècle, Japon.
538: Motif ornemental, brocart, Inde.

535: U.S.S.R., 19th century.
536: Aegina, Ancient Greece.
537: Japan, 8th-11th centuries.
538: Brocade motif. India.

535: XIX. Jahrh., UdSSR.
536: Ägina, Griechenland.
537: VIII. - XI. Jahrh., Japan.
538: Brokat, Indien.

535

535

536

537

538

539: Motif ornemental, ivoire, Vizagapatam, Inde.

539: Ivory motif. Vizagapatam, India.

539: Elfenbein, Vizagapatam, Indien.

540: Motif ornemental, 1^{er} millénaire av. J.-C., Crète.
541: Motif ornemental, Congo.
542: Frise d'oves et chapelet, Erechthéion, Athènes, Grèce.
543: Frise, Ceylan.

540: Crete, 1st millennium BC.
541: Congo.
542: Egg-and-dart frieze motif. Erechtheion, Athens, Greece.
543: Frieze motif. Ceylon.

540: 1. Jahrtausend v. Chr., Kreta.
541: Kongo.
542: Fries mit Eierschnur, Erechtheion, Athen, Griechenland.
543: Fries, Ceylon.

540

541 541

542 542

543

544

544

544: Motif ornemental, Japon.
545: Motif ornemental, Zambèze, Afrique.
546: Motif ornemental, Zambèze, Afrique.
547: Chapiteau, peinture, style dorique, Grèce.

544: Japan.
545: Zambezi Basin, Central Africa.
546: Zambezi Basin, Central Africa.
547: Painted Doric capital. Greece.

544: Japan.
545: Sambesi, Afrika.
546: Sambesi, Afrika.
547: Kapitell, Malerei, dorisch, Griechenland.

545

546

547

548: Motif ornemental, art minoen, XVI^me siècle
av. J.-C., Crète.
549: Peltes, mosaïque, art gréco-romain, III^me-
IV^me siècle.

548: Minoan motif. Crete, 16th century BC.
*549: Graeco-Roman mosaic pelta motif. 3rd-
4th centuries.*

548: Minoisch, XVI. Jahrh. v. Chr., Kreta.
549: Schildchen-Mosaik, griechisch-römisch, III.
- IV. Jahrh.

548

548

549

549

550

550

550

550

551

551

552

552

553

554: Motif ornemental, 1er millénaire av. J.-C.,
Nimroud, Mésopotamie.
555: Tissu, XVme-XVIme siècle, Italie.

554: Nimrud, Mesopotamia, 1st millennium BC.
555: Textile motif. Italy, 15th-16th centuries.

554: 1. Jahrtausend v. Chr., Nimrud, Mesopota-
mien.
555: Gewebe, XV. - XVI. Jahrh., Italien.

554

554

555

555

556

557

557

558

559

556: Motif ornemental, 2ᵐᵉ millénaire av. J.-C.,
ruines de Tello, Lagash, Mésopotamie.
557: Motif ornemental, art roman, Xᵐᵉ siècle,
France.
558: Tissu, art musulman.
559: Palmes, céramique, VIIIᵐᵉ siècle, Chine.

*556: Tello, Lagash, Mesopotamia, 2nd millen-
nium BC.*
557: Romanesque motif. France, 10th century.
558: Islamic textile motif.
*559: Ceramic palm leaf motif. China, 8th cen-
tury.*

556: 2. Jahrtausend v. Chr., Ruinen von Tello,
Lagasch, Mesopotamien.
557: Romanisch, X. Jahrh., Frankreich.
558: Gewebe, muselmanisch.
559: Palmen, Keramik, VIII. Jahrh., China.

560: Tissu, art musulman.
561: Peinture murale, Maoris, Nouvelle-Zélande.
562: Bordure de tapis, art musulman.

560: Islamic textile design.
561: Maori mural painting motif. New Zealand.
562: Islamic carpet border motif.

560: Gewebe, muselmanisch.
561: Wandbemalung, Maori, Neuseeland.
562: Teppichbordüre, muselmanisch.

560 560

561 561

562

562

563

563

563: Céramique, XXᵐᵉ siècle, Italie.
564: Tissu, XIXᵐᵉ siècle, Roumanie.

563: Ceramic motif. Italy, 20th century.
564: Textile motif. Romania, 19th century.

563: Kachel, XX. Jahrh., Italien.
564: Gewebe, XIX. Jahrh., Rumänien.

564

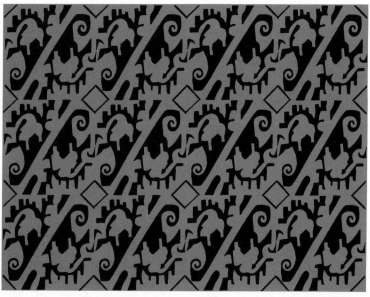

564

565: Motif ornemental alterné, Japon.
566: Motif ornemental alterné, IX^me-VIII^me siècle
 av. J.-C., Chine.
567: Tissu indien, Mexique.
568: Motif ornemental, XVII^me siècle, Italie.

565: Alternating motif. Japan.
566: Alternating motif. China, 9th-8th centuries
* BC.*
567: Indian textile motif. Mexico.
568: Italy, 17th century.

565: Japan.
566: IX. - VIII. Jahrh. v. Chr., China.
567: Indianisches Gewebe, Mexiko.
568: XVII. Jahrh., Italien.

565

565

566

567

568

569

570

570

571

571

572

573

574: Grille, bronze, Turquie.
575: Céramique, XXᵐᵉ siècle, Italie.

574: Bronze grille. Turkey.
575: Ceramic motif. Italy, 20th century.

574: Gitter, Bronze, Türkei.
575: Kachel, XX. Jahrh., Italien.

574

574

575

575

576

576

576: Nacre, Turquie.
577: Céramique, XX^me siècle, Italie.

576: Mother-of-pearl inlay motif. Turkey.
577: Ceramic motif. Italy, 20th century.

576: Perlmutter, Türkei.
577: Kachel, XX. Jahrh., Italien.

577

577

578: Frise, Chine.
579: Frise, IIIᵐᵉ-VIIᵐᵉ siècle, Sassanides, Iran.
580: Motif ornemental, XVIᵐᵉ siècle, Turquie.
581: Batik, Koueitcheou, Chine.

578: Frieze motif. China.
579: Sassanid period frieze motif. Persia, 3rd-
7th centuries.
580: Turkey, 16th century.
581: Batik motif. Kweichow, China.

578: Fries, China.
579: Fries, III. - VII. Jahrh., Sassaniden, Iran.
580: XVI. Jahrh., Türkei.
581: Batik, Kueitschou, China.

578

579

580

581

581

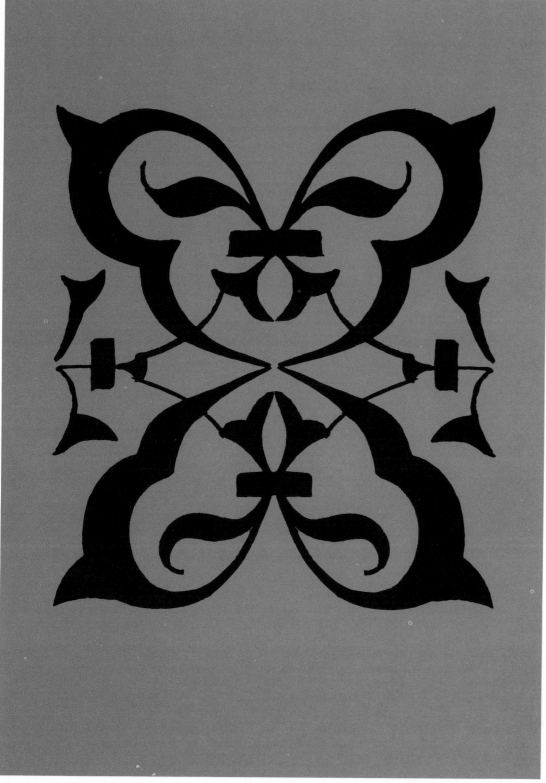

582: En-tête de page, XVIIᵐᵉ siècle, France.

582: *Printer's headpiece. France, 17th century.*

582: Kopf einer Seite, XVII. Jahrh., Frankreich.

582

583 : Motif ornemental inversé, céramique, Vme-
 VIIme siècle, Pérou.
584 : Bordure de tapis, Turquie.
585 : Griffe de dragon, tapis, Turquie.
586 : Céramique, Brésil.

583 : Ceramic motif. Peru, 5th-7th centuries.
584 : Carpet border motif. Turkey.
585 : Dragon-claw carpet motif. Turkey.
586 : Ceramic motif. Brazil.

583 : Umgekehrtes Ornament-Motiv, Keramik,
 V. - VII. Jahrh., Peru.
584 : Teppich-Bordüre, Türkei.
585 : Drachentatze, Teppich, Türkei.
586 : Keramik, Brasilien.

583

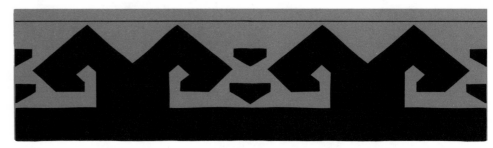

584

585 585

586

587

588

589

590

591: Motif ornemental, Bakubas, Congo.
592: Motif ornemental, Hawaii.

591: Bakuba motif. Congo.
592: Hawaii.

591: Bakuba, Afrika.
592: Hawai, Ozeanien.

591

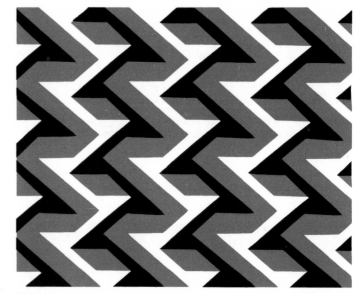

591

592

592

593

593

593: Motif ornemental, Cameroun.
594: Tapis, Turkmènes, Asie Centrale.

593: Cameroon.
594: Carpet motif. Turkestan, Central Asia.

593: Kamerun.
594: Teppich, turkmenisch, Zentral-Asien.

594

594

595: Mosaïque, Barcino, Espagne.
596: Tracé géométrique, art arabe.

595: *Mosaic motif. Barcino, Spain.*
596: *Arab outline motif.*

595: Mosaik, Barcino, Spanien.
596: Geometrische Zeichnung, arabisch.

595

595

596

596

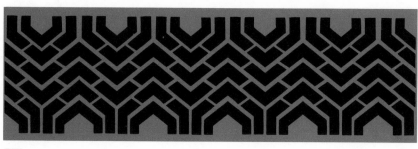

597

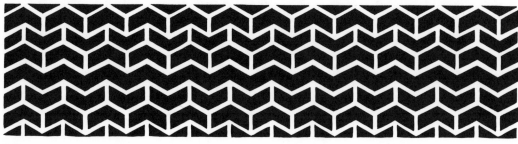

598

599

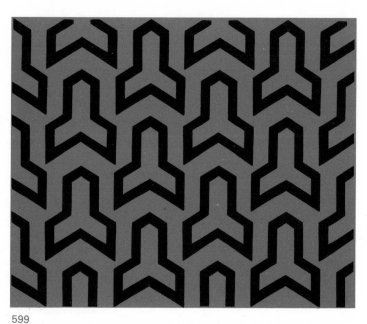

599

597: Profil de pneu.
598: Profil de pneu.
599: Motif ornemental, XIXme siècle, Japon.

597: Tyre tread.
598: Tyre tread.
599: Japan, 19th century.

597: Profil eines Autoreifens.
598: Profil eines Autoreifens.
599: XIX. Jahrh., Japan.

**Motifs ornementaux
issus de végétaux**

**Ornaments based on vegetable
forms**

**Ornament-Motive aus der
Pflanzenwelt**

600

601

600: Motif ornemental, Japon.
601: Motif ornemental, art proto-attique, Grèce.
602: Palmette, Athènes, Grèce.
603: Céramique, Grèce.
604: Motif ornemental, 2me millénaire av. J.-C., Mésopotamie.
605: Palmette, Amadan, Iran.
606: Palmettes inversées, céramique, Grèce.
607: Palmette, céramique, Grèce.

600: Japan.
601: Proto-Attic motif. Greece.
602: Palmette motif. Athens, Ancient Greece.
603: Ceramic motif. Ancient Greece.
604: Mesopotamia, 2nd millennium BC.
605: Palmette motif. Amadan, Persia.
606: Ceramic reversed palmette motif. Ancient Greece.
607: Ceramic palmette motif. Ancient Greece.

600: Japan.
601: Proto-attisch, Griechenland.
602: Palmette, Athen, Griechenland.
603: Keramik, Griechenland.
604: 2. Jahrtausend v. Chr., Mesopotamien.
605: Palmette, Amadan, Iran.
606: Gegeneinandergestellte Palmetten, Keramik, Griechenland.
607: Palmette, Keramik, Griechenland.

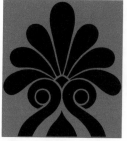

602

603

604

605

605

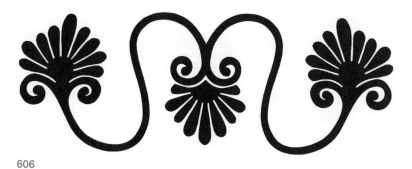

606

607

600-607 **161**

608: Palmette, Athènes, Grèce.
609: Frise, céramique, Grèce.
610: Palmette, céramique, Grèce.
611: Vignette typographique, Empire, France.
612: Motif ornemental inspiré par le style grec, Second Empire, France.
613: Frise, Pompéi, Italie.

608: Palmette motif. Athens, Ancient Greece.
609: Ceramic frieze motif. Ancient Greece.
610: Ceramic palmette motif. Ancient Greece.
611: Empire type ornament. France.
612: Second Empire Grecian motif. France.
613: Roman frieze motif. Pompeii, Italy.

608: Palmette, Athen, Griechenland.
609: Fries, Keramik, Griechenland.
610: Palmette, Keramik, Griechenland.
611: Typographische Vignette, Empire, Frankreich.
612: Griechisch beeinflusstes Ornament-Motiv, Zweites Kaiserreich, Frankreich.
613: Fries, Pompeji, Italien.

608

609

610

611

612

612

613

614

615

616

617

618

614: Motif ornemental, XVIIIᵐᵉ siècle, Japon.
615: Motif ornemental inspiré par le style grec, Second Empire, France.
616: Motif ornemental répété, Babylone, Méso-potamie.
617: Motif ornemental, XVIIIᵐᵉ siècle, Japon.
618: Motif ornemental, Empire, France.
619: Motif ornemental, Empire, France.
620: Motif ornemental inspiré par le style grec, Second Empire, France.
621: Frise, Empire, France.

614: Japan, 18th century.
615: Second Empire Grecian motif. France.
616: Babylon, Mesopotamia.
617: Japan, 18th century.
618: Empire motif. France.
619: Empire motif. France.
620: Second Empire Grecian motif. France.
621: Empire frieze motif. France.

614: XVIII. Jahrh., Japan.
615: Griechisch beeinflusstes Ornament-Motiv, Zweites Kaiserreich, Frankreich.
616: Babylonien, Mesopotamien.
617: XVIII. Jahrh., Japan.
618: Empire, Frankreich.
619: Empire, Frankreich.
620: Griechisch beeinflusstes Ornament-Motiv, Zweites Kaiserreich, Frankreich.
621: Fries, Empire, Frankreich.

619

620

621

622: Motif ornemental, XIVᵐᵉ siècle, Lucques, Italie.
623: Motif ornemental, Empire, France.
624: Motif ornemental, Maroc.
625: Motif ornemental inspiré par le style grec, Second Empire, France.
626: Bronze, âge du fer, Chypre.
627: Vignette typographique (Deberny et Peignot), début XXᵐᵉ siècle, Paris, France.
628: Frise, Bali, Indonésie.

622: Lucca, Italy, 14th century.
623: Empire motif. France.
624: Morocco.
625: Second Empire Grecian motif. France.
626: Bronze, Iron Age, Ancient Cyprus.
627: Type ornament, cast by Deberny and Peignot. Paris, France, beginning of 20th century.
628: Frieze motif. Bali, Indonesia.

622: XIV. Jahrh., Lucca, Italien.
623: Empire, Frankreich.
624: Marokko.
625: Griechisch beeinflusstes Ornament-Motiv, Zweites Kaiserreich, Frankreich.
626: Eisenzeit, Bronze, Zypern.
627: Typographische Vignette (Deberny und Peignot), Anfang des XX. Jahrh., Paris, Frankreich.
628: Fries, Bali, Indonesien.

622

623

624

625

626

627

628

629

629: Palmette, Turkestan chinois.

629: Palmette motif. Chinese Turkestan.

629: Palmette, Chinesisch-Turkestan.

630: Motif ornemental, Bharut, Inde.
631: Motif ornemental, Bharut, Inde.
632: Motif ornemental, Allahabad, Inde.
633: Motif ornemental, Mathura, Inde.
634: Motif ornemental, Allahabad, Inde.
635: Motif ornemental, XIVᵐᵉ siècle, Venise, Italie.
636: Motif ornemental, 1ᵉʳ millénaire av. J.-C., Nimroud, Mésopotamie.

630: Bharut, India.
631: Bharut, India.
632: Allahabad, India.
633: Mathura, India.
634: Allahabad, India.
635: Venice, Italy, 14th century.
636: Nimrud, Mesopotamia, 1st millennium BC.

630: Bharut, Indien.
631: Bharut, Indien.
632: Allahabad, Indien.
633: Mathura, Indien.
634: Allahabad, Indien.
635: XIV. Jahrh., Venedig, Italien.
636: 1. Jahrtausend v. Chr., Nimrud, Mesopotamien.

630

631

632

633

634

635

636

636

637

638

637: Motif ornemental, 1er millénaire av. J.-C.,
Nimroud, Mésopotamie.
638: Motif ornemental, XVIIme siècle, Norvège.
639: Motif ornemental, tombe phénicienne,
1er millénaire av. J.-C., Syrie.
640: Fleur de lotus, 1er millénaire av. J.-C.,
Mésopotamie.
641: Fleur de lotus, époque des Pharaons,
Egypte.

637: Nimrud, Mesopotamia, 1st millennium BC.
638: Norway, 17th century.
639: Alternating motif from a Phoenician tomb.
Syria, 1st millennium BC.
640: Lotus motif. Mesopotamia, 1st millennium
BC.
641: Lotus motif. Ancient Egypt.

637: 1. Jahrtausend v. Chr., Nimrud, Mesopo-
tamien.
638: XVII. Jahrh., Norwegen.
639: Phönizisches Grab, 1. Jahrtausend v. Chr.,
Syrien.
640: Lotosblume, 1. Jahrtausend v. Chr., Meso-
potamien.
641: Lotosblume, Pharaonen-Zeit, Ägypten.

639

639

640

640

641

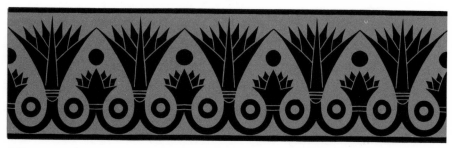

641

642: Fleur de lis, XIVᵐᵉ siècle, Syrie.
643: Fleur de lis, XVIIIᵐᵉ siècle, France.
644: Fleur de lis, XVᵐᵉ siècle, Italie.
645: Fleur de lis, XVIIᵐᵉ siècle, Florence, Italie.
646: Vignette, XVIIIᵐᵉ siècle, France.
647: Motif ornemental, broderie, Inde.
648: Motif ornemental, Kish, Mésopotamie.
649: Motif ornemental, Turkestan chinois.
650: Motif ornemental, XIVᵐᵉ siècle, Syrie.
651: Motif ornemental, Maroc.

642: Fleur de lys. Syria, 14th century.
643: Fleur de lys. France, 18th century.
644: Fleur de lys. Italy, 15th century.
645: Fleur de lys. Florence, Italy, 17th century.
646: Printer's ornament. France, 18th century.
647: Embroidery motif. India.
648: Kish, Mesopotamia.
649: Chinese Turkestan.
650: Syria, 14th century.
651: Morocco.

642: Heraldische Lilie, XIV. Jahrh., Syrien
643: Heraldische Lilie, XVIII. Jahrh., Frankreich.
644: Heraldische Lilie, XV. Jahrh., Italien.
645: Heraldische Lilie, XVII. Jahrh., Florenz, Italien.
646: Vignette, XVIII. Jahrh., Frankreich.
647: Stickerei, Indien.
648: Kisch, Mesopotamien.
649: Chinesisch-Turkestan.
650: XIV. Jahrh., Syrien.
651: Marokko.

642

643

644

645

646

647

648

649

650

651

652

653

654

655

655

656

656

657

658

659

660

652-660 **169**

661: Motif ornemental, art hispano-mauresque,
XVIᵐᵉ siècle, Espagne.
662: Tissu, XVIᵐᵉ siècle, Italie.
663: Tissu, XVIᵐᵉ siècle, Italie.
664: Tissu, XVIᵐᵉ siècle, Italie.
665: Tissu, XVIᵐᵉ siècle, Italie.
666: Motif ornemental, XVIIIᵐᵉ siècle, Rouma-
nie.
667: Motif ornemental, époque 1900, France.
668: Tissu, XVIᵐᵉ siècle, Espagne.
669: Motif ornemental, XVIᵐᵉ siècle, Espagne
ou Italie.

661: *Morisco motif. Spain, 16th century.*
662: *Textile motif. Italy, 16th century.*
663: *Textile motif. Italy, 16th century.*
664: *Textile motif. Italy, 16th century.*
665: *Textile motif. Italy, 16th century.*
666: *Romania, 18th century.*
667: *France, end of 19th century.*
668: *Textile motif. Spain, 16th century.*
669: *Spain, or Italy, 16th century.*

661: Spanisch-maurisch, XVI. Jahrh., Spanien.
662: Gewebe, XVI. Jahrh., Italien.
663: Gewebe, XVI. Jahrh., Italien.
664: Gewebe, XVI. Jahrh., Italien.
665: Gewebe, XVI. Jahrh., Italien.
666: XVIII. Jahrh., Rumänien.
667: Um 1900, Frankreich.
668: Gewebe, XVI. Jahrh., Spanien.
669: XVI. Jahrh. Spanien oder Italien.

661

662

663

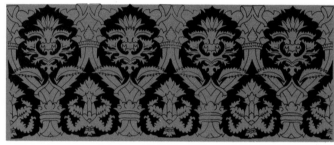

664

665

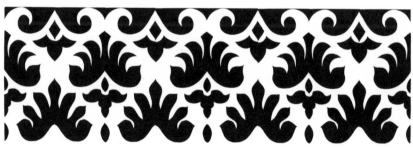

665

666

667

668

669

670

671

672

673

673

674

674

675

676

677

678

679: Motif ornemental, Bornéo.
680: Motif ornemental, Bornéo.
681: Motif ornemental, XXᵐᵉ siècle, Yougoslavie.
682: Cuir brodé, XXᵐᵉ siècle, Turquie.
683: Motif ornemental, époque Nara, VIIIᵐᵉ-Xᵐᵉ siècle, Japon.
684: Motif ornemental, époque Ming, XVIᵐᵉ siècle, Chine.
685: Motif ornemental, Afrique du Nord-Ouest.
686: Motif ornemental, Turkestan chinois.

679: Borneo.
680: Borneo.
681: Yugoslavia, 20th century.
682: Motif from embroidered leatherwork. Turkey, 20th century.
683: Nara period motif. Japan, 8th-10th centuries.
684: Ming period motif. China, 16th century.
685: North-West Africa.
686: Chinese Turkestan.

679: Borneo.
680: Borneo.
681: XX. Jahrh., Jugoslawien.
682: Besticktes Leder, XX. Jahrh., Türkei.
683: Nara-Epoche, VIII. - X. Jahrh., Japan.
684: Ming, XVI. Jahrh., China.
685: Nord-West Afrika.
686: Chinesisch-Turkestan.

679

680

681

682

683

684

685

686

687

688

689

690

691

692

693

694

695

696

697

698

699

700

701

702

703

704

705

706

707

708

709

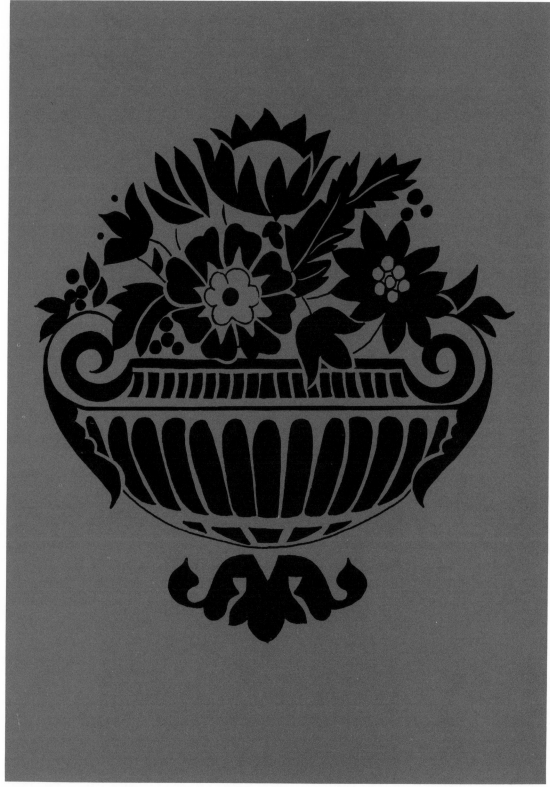

710: Motif ornemental, Empire, France.

710: Empire motif. France, 19th century.

710: Empire, Frankreich.

710

711 : Tapis, Pékin, Chine.
712 : Motif ornemental, art copte, Egypte.
713 : Motif ornemental, XVIᵐᵉ siècle, Italie.
714 : Motif ornemental, Japon.
715 : Motif ornemental, XIVᵐᵉ siècle, Japon.
716 : Motif ornemental, Algérie.
717 : Plat, or, époque Song, Xᵐᵉ-XIᵐᵉ siècle, Chine.
718 : Motif ornemental, Empire, France.
719 : Motif ornemental, Nouvel Empire, Egypte.
720 : Vignette typographique, début du XXᵉ siècle, France.

711 : Carpet motif. Peking, China.
712 : Coptic motif. Egypt.
713 : Italy, 16th century.
714 : Japan.
715 : Japan, 14th century.
716 : Algeria.
717 : Song period motif from a golden dish. China, 10th-11th centuries.
718 : Empire motif. France, 19th century.
719 : New Empire period motif. Egypt.
720 : Type ornament. France, beginning of 20th century.

711 : Teppich, Peking, China.
712 : Koptisch, Ägypten.
713 : XVI. Jahrh., Italien.
714 : Japan.
715 : XIV. Jahrh., Japan.
716 : Algerien.
717 : Platte, Gold, Sung-Zeit, X. - XI. Jahrh., China.
718 : Empire, Frankreich.
719 : Neues Reich, Ägypten.
720 : Typographische Vignette, Anfang des XX. Jahrh., Frankreich.

711

712

713

714

715

716

717

718

719

720

721

722

723

724

725

726

727

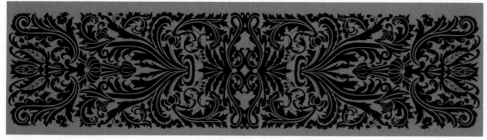

727

728

729: Motif ornemental, XVIIIᵐᵉ siècle, Suisse.
730: Tissu, XVIᵐᵉ siècle, Italie.
731: Tissu, XVIᵐᵉ siècle, Italie.
732: Tissu, XVIᵐᵉ siècle, Espagne.
733: Motif ornemental, Maoris, Nouvelle-Zélande.
734: Soie damassée, XVIIᵐᵉ siècle, Chine.
735: Motif ornemental, IIIᵐᵉ-VIᵐᵉ siècle, Alexandrie, Egypte.
736: Motif ornemental, XVIIᵐᵉ siècle, Flandres.

729: Switzerland, 18th century.
730: Textile motif. Italy, 16th century.
731: Textile motif. Italy, 16th century.
732: Textile motif. Spain, 16th century.
733: Maori motif. New Zealand.
734: Motif from silk damask. China, 17th century.
735: Alexandria, Egypt, 3rd-6th centuries.
736: Flanders, 17th century.

729: XVIII. Jahrh., Schweiz.
730: Gewebe, XVI. Jahrh., Italien.
731: Gewebe, XVI. Jahrh., Italien.
732: Gewebe, XVI. Jahrh., Spanien.
733: Maori, Neuseeland.
734: Seidendamast, XVII. Jahrh., China.
735: III. - VI. Jahrh., Alexandrien, Ägypten.
736: XVII. Jahrh., Flandern.

729

730

731

732

733

734

735

736

737

738

739

740

741

742

743

744

745

746

747: Motif ornemental, Japon.
748: Céramique, Sind, Pakistan occidental.
749: Motif ornemental, Japon.
750: Vignette typographique (Deberny et Peignot), début du XX^me siècle, Paris, France.
751: Vignette typographique (Deberny et Peignot), début du XX^me siècle, Paris, France.
752: Motif ornemental, XIX^me siècle, Suède.
753: Cul-de-lampe, gravure sur bois, XVII^me siècle, France.

747: Japan.
748: Ceramic motif. Sind, Pakistan.
749: Japan.
750: Type ornament, cast by Deberny and Peignot. Paris, France, beginning of 20th century.
751: Type ornament, cast by Deberny and Peignot. Paris, France, beginning of 20th century.
752: Sweden, 19th century.
753: Printer's ornament. France, 17th century.

747: Japan.
748: Keramik, Sind, West-Pakistan.
749: Japan.
750: Typographische Vignette (Deberny und Peignot), Anfang des XX. Jahrh., Paris, Frankreich.
751: Typographische Vignette (Deberny und Peignot), Anfang des XX. Jahrh., Paris, Frankreich.
752: XIX. Jahrh., Schweden.
753: Vignette, Holzschnitt, XVII. Jahrh., Frankreich.

747

748

749

750

751

752

753

754

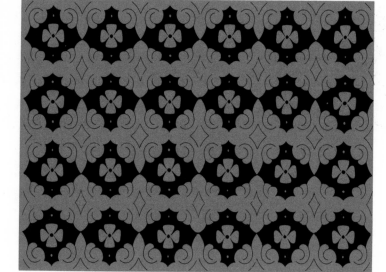

754: Incrustation de nacre et ivoire, XIX^{me} siècle, Rajasthan, Inde.
755: Céramique, XVIII^{me}-XIX^{me} siècle, Inde.

754: Ivory and mother-of-pearl inlay motif. Rajasthan, India, 19th century.
755: Ceramic. India, 18th-19th centuries.

754: Intarsien von Perlmutter und Elfenbein, XIX. Jahrh., Rajasthan, Indien.
755: Kachel, XVIII. - XIX. Jahrh., Indien.

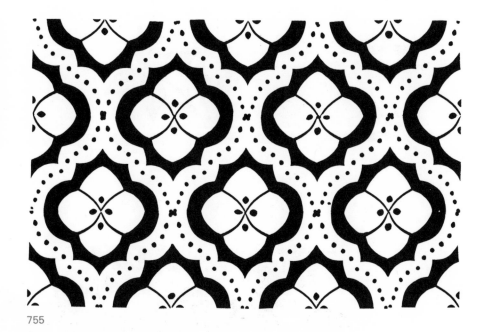

754

755

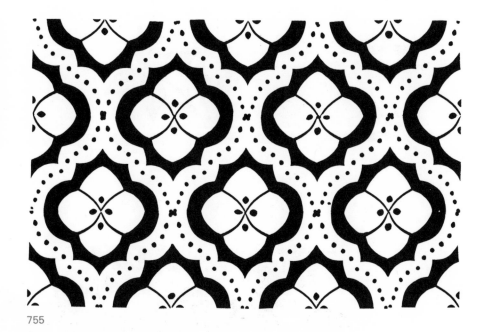

755

756 : Bloc à imprimer la faïence, Bamu, Inde.
757 : Motif ornemental, époque Louis XVI, France.
758 : Motif ornemental, époque Louis XVI, France.
759 : Motif ornemental, époque Louis XVI, France.
760 : Motif ornemental, époque Louis XVI, France.
761 : Motif ornemental, époque Louis XVI, France.

756 : Printing block for ceramic. Bamu, India.
757 : Louis XVI motif. France.
758 : Louis XVI motif. France.
759 : Louis XVI motif. France.
760 : Louis XVI motif. France.
761 : Louis XVI motif. France.

756 : Druckstock für Fayence, Bamu, Indien.
757 : Louis-seize-Stil, Frankreich.
758 : Louis-seize-Stil, Frankreich.
759 : Louis-seize-Stil, Frankreich.
760 : Louis-seize-Stil, Frankreich.
761 : Louis-seize-Stil, Frankreich.

756

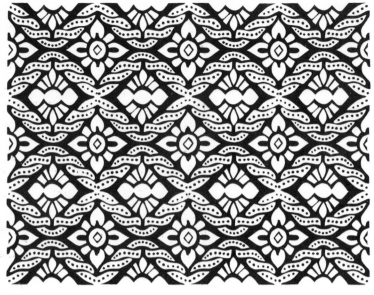

756

757

758

759

760

761

762: Incrustation de marbre, Fort-Rouge, Agra, Inde.

762: *Marble inlay motif. Red Fort, Agra, India.*

762: Eingelegter Marmor, Palast des Roten Forts, Agra, Indien.

762

762 **183**

763 : Sari, XIXᵐᵉ siècle, Dacca, Pakistan oriental.
764 : Tissu, Assam, Inde.
765 : Motif ornemental, XIXᵐᵉ siècle, U.R.S.S.
766 : Vase, métal, Inde.

763: Motif on sari. Dacca, East Pakistan, 19th century.
764: Textile motif. Assam, India.
765: U.S.S.R., 19th century.
766: Motif from metal vase. India.

763 : Sari, XIX. Jahrh., Dacca, Ost-Pakistan.
764 : Gewebe, Assam, Indien.
765 : XIX. Jahrh., UdSSR.
766 : Metallvase, Indien.

763

764

765

766

767

768

769

769

770

771

771

772: Céramique, XIme-XIIme siècle, Brésil.
773: Extrait d'un bandeau, Vme-IIIme siècle av. J.-C., Chine.
774: Vignette typographique (Deberny et Peignot), début du XXme siècle, Paris, France.
775: Vignette typographique (Deberny er Peignot), début du XXme siècle, Paris, France.
776: Motif ornemental, époque 1900.
777: Vignette typographique (Deberny et Peignot), début du XXme siècle, Paris, France.
778: Motif ornemental, 1er siècle av. J.-C., Chine.
779: Motif ornemental, XVIIIme siècle, Chine.
780: Tissu, art copte, Egypte.
781: Vignette typographique (Deberny et Peignot), début du XXme siècle, Paris, France.
782: Vignette typographique (Deberny et Peignot), début du XXme siècle, Paris, France.

772: Ceramic motif. Brazil, 11th-12th centuries.
773: Section of panel ornament. China, 5th-3rd centuries BC.
774: Type ornament, cast by Deberny and Peignot. Paris, France, beginning of 20th century.
775: Type ornament, cast by Deberny and Peignot. Paris, France, beginning of 20th century.
776: End of 19th century.
777: Type ornament, cast by Deberny and Peignot. Paris, France, beginning of 20th century.
778: China, 1st century BC.
779: China, 18th century.
780: Coptic textile motif. Egypt.
781: Type ornament, cast by Deberny and Peignot. Paris, France, beginning of 20th century.
782: Type ornament, cast by Deberny and Peignot. Paris, France, beginning of 20th century.

772: Keramik, XI. - XII. Jahrh., Brasilien.
773: Ausschnitt aus einem Band, V. - III. Jahrh. v. Chr., China.
774: Typographische Vignette (Deberny und Peignot), Anfang des XX. Jahrh., Paris, Frankreich.
775: Typographische Vignette (Deberny und Peignot), Anfang des XX. Jahrh., Paris, Frankreich.
776: Um 1900.
777: Typographische Vignette (Deberny und Peignot), Anfang des XX. Jahrh., Paris, Frankreich.
778: I. Jahrh. v. Chr., China.
779: XVIII. Jahrh., China.
780: Gewebe, koptisch, Ägypten.
781: Typographische Vignette (Deberny und Peignot), Anfang des XX. Jahrh., Paris, Frankreich.
782: Typographische Vignette (Deberny und Peignot), Anfang des XX. Jahrh., Paris, Frankreich.

772

773

774

775

776

777

778

779

780

781

782

783 784 785

783: Vignette, fin du XIX^me siècle, France.
784: Vignette, XVI^me siècle, France.
785: Bouquet symétrique, époque Ming, XVII^me siècle, Chine.
786: Bouquet symétrique, Khâsis, Inde.
787: Bouquet asymétrique, Turkestan chinois.
788: Vignette typographique (Deberny et Peignot), début du XX^me siècle, Paris, France.
789: Tissu, XV^me siècle, Italie.
790: Tissu, XVI^me siècle, Espagne.
791: Tissu, époque Louis XIV, France.
792: Motif ornemental, Renaissance, Allemagne.

786 787 788

783: Printer's ornament. France, end of 19th century.
784: Printer's ornament. France, 16th century.
785: Ming symmetrical bouquet motif. China, 17th century.
786: Symmetrical bouquet motif. Khasis, India.
787: Asymmetrical bouquet motif. Chinese Turkestan.
788: Type ornament, cast by Deberny and Peignot. Paris, France, beginning of 20th century.
789: Italy, 15th century.
790: Textile motif. Spain, 16th century.
791: Louis XIV textile motif. France.
792: Renaissance motif. Germany.

789 789 790

783: Vignette, Ende des XIX. Jahrh., Frankreich.
784: Vignette, XVI. Jahrh., Frankreich.
785: Symmetrisches Bukett, Ming, XVII. Jahrh., China.
786: Symmetrisches Bukett, Khasis, Indien.
787: Unsymmetrisches Bukett, Chinesisch, Turkestan.
788: Typographische Vignette (Deberny und Peignot), Anfang des XX. Jahrh., Paris, Frankreich.
789: Gewebe, XV. Jahrh., Italien.
790: Blumen, XVI. Jahrh., Spanien.
791: Gewebe, Louis-quatorze-Stil, Frankreich.
792: Renaissance, Deutschland.

791 792

793 : Tissu, XVᵐᵉ-XVIᵐᵉ siècle, Italie.
794 : Vignette, XVIᵐᵉ siècle, Lyon, France.
795 : Céramique, Bombay, Inde.
796 : Céramique, XIXᵐᵉ siècle, Jaipur, Inde.

793: Textile motif. Italy, 15th-16th centuries.
794: Printer's ornament. Lyons, France, 16th century.
795: Ceramic motif. Bombay, India.
796: Ceramic motif. Jaipur, India, 19th century.

793 : Gewebe, XV. - XVI. Jahrh., Italien.
794 : Vignette, XVI. Jahrh., Lyon, Frankreich.
795 : Keramik, Bombay, Indien.
796 : Keramik, XIX. Jahrh., Jaipur, Indien.

793

794

795

795

796

797

798

799

800

801

797: Vignette typographique (Deberny et Peignot), début du XX^{me} siècle, Paris, France.
798: Céramique, Jaipur, Inde.
799: Bordure de tapis, Pékin, Chine.
800: Motif ornemental, XVIII^{me} siècle, Glaris, Suisse.
801: Motif ornemental, XVII^{me} siècle, Turquie.

797: Type ornament, cast by Deberny and Peignot. Paris, France, beginning of 20th century.
798: Ceramic motif. Jaipur, India.
799: Carpet border motif. Peking, China.
800: Glaris, Switzerland, 18th century.
801: Turkey, 17th century.

797: Typographische Vignette (Deberny und Peignot), Anfang des XX. Jahrh., Paris, Frankreich.
798: Keramik, Jaipur, Indien.
799: Teppichbordüre, Peking, China.
800: XVIII. Jahrh., Glarus, Schweiz.
801: XVII. Jahrh., Türkei.

802: Motif ornemental, époque Ts'ing, XVIII^{me} siècle, Chine.
803: Motif ornemental, époque Ming, XVI^{me} siècle, Chine.
804: Motif ornemental, Brousse, Turquie.
805: Motif ornemental, XII^{me} siècle, Chine.

802: *Ching period motif. China, 18th century.*
803: *Ming period motif. China, 16th century.*
804: *Brousse, Turkey.*
805: *China, 12th century.*

802: Tsing, XVIII. Jahrh., China.
803: Ming, XVI. Jahrh., China.
804: Brousse, Türkei.
805: XII. Jahrh., China.

802

803

804

805

806: Motif ornemental symbolique «jou-yi» (selon votre désir), XVIII^me siècle, Chine.

806: Symbol jou-yi ('according to your wish'). China, 18th century.

806: Symbolisches Ornament-Motiv «jou-yi» («nach Ihrem Wunsch»), XVIII. Jahrh., China.

806

807: Motif ornemental, IIIme siècle, Iran.
808: Frise, art copte, Egypte.
809: Céramique, Barcelone, Espagne.
810: Motif ornemental, époque Song, Xme-XIIIme siècle, Chine.

807: Persia, 3rd century.
808: Coptic frieze motif. Egypt.
809: Ceramic motif. Barcelona, Spain.
810: Song period motif. China, 10th-13th centuries.

807: III. Jahrh., Iran.
808: Fries, koptisch, Ägypten.
809: Keramik, Barcelona, Spanien.
810: Sung-Zeit, X. - XIII. Jahrh., China.

807

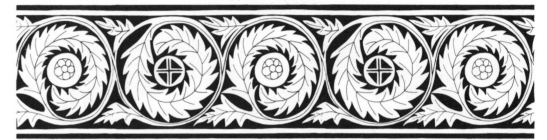

808

809

810

811

812

813

813

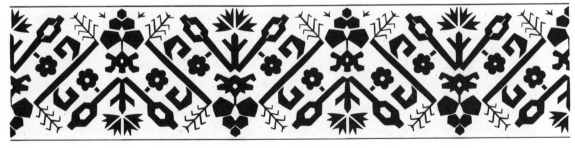

814

815: Motif ornemental, Ceylan.
816: Motif ornemental, Empire, France.
817: Motif ornemental, Empire, France.
818: Frise, art romain.

815: Ceylon.
816: Empire motif. France.
817: Empire motif. France.
818: Ancient Roman frieze motif.

815: Ceylon.
816: Empire, Frankreich.
817: Empire, Frankreich.
818: Fries, römisch.

815

815

816

817

818

819 820 821

822 823 824

825 826 827 828

829

819: Fleur de lis, Cnossos, Crète.
820: Motif ornemental, Pylos, Grèce.
821: Peltes, mosaïque, art gréco-romain.
822: Motif ornemental (frise) Kirghizistan, U.R.S.S.
823: Vignette typographique (Deberny et Peignot), début du XXᵐᵉ siècle, Paris, France.
824: Vignette typographique (Deberny et Peignot), début du XXᵐᵉ siècle, Paris, France.
825: Vignette typographique, XVIIIᵐᵉ siècle, France.
826: Motif ornemental, Pompéi, Italie.
827: Faïence, Turquie.
828: Motif ornemental, XVIIIᵐᵉ siècle, Appenzell, Suisse.
829: Vignette typographique (Deberny et Peignot), début du XXᵐᵉ siècle, Paris, France.

819: Fleur de lys. Cnossos, Crete.
820: Pylos, Greece.
821: Graeco-Roman mosaic pelta motif.
822: Frieze motif. Kirghizia, U.S.S.R.
823: Type ornament, cast by Deberny and Peignot. Paris, France, beginning of 20th century.
824: Type ornament, cast by Deberny and Peignot. Paris, France, beginning of 20th century.
825: Type ornament. France, 18th century.
826: Roman motif. Pompeii, Italy.
827: Ceramic motif. Turkey.
828: Appenzell, Switzerland, 18th century.
829: Type ornament, cast by Deberny and Peignot. Paris, France, beginning of 20th century.

819: Heraldische Lilie, Knossos, Kreta.
820: Pylos, Griechenland.
821: Schildchen-Mosaik, griechisch-römisch.
822: Fries, Kirghisistan, UdSSR.
823: Typographische Vignette (Deberny und Peignot), Anfang des XX. Jahrh., Paris, Frankreich.
824: Typographische Vignette (Deberny und Peignot), Anfang des XX. Jahrh., Paris, Frankreich.
825: Typographische Vignette, XVIII. Jahrh., Frankreich.
826: Pompeji, Italien.
827: Fayence, Türkei.
828: XVIII. Jahrh., Appenzell, Schweiz.
829: Typographische Vignette (Deberny und Peignot), Anfang des XX. Jahrh., Paris, Frankreich.

830: Motif ornemental, XVIIme siècle, Italie.
831: Tombeau, VIIme siècle, Chine.
832: Frise, Directoire, France.
833: Motif ornemental, Second Empire, France.
834: Plat, IVme-IIIme siècle av. J.-C., Chine.
835: Motif ornemental, époque Ming, XVIme siècle, Chine.
836: Motif ornemental, IIIme siècle av. J.-C., Chine.
837: Brocart, Bénarès, Inde.
838: Bois gravé pour l'impression des tissus, XXme siècle, Lucknow, Inde.
839: Bois gravé pour l'impression des tissus, Inde.
840: Bijou, XIXme siècle, Inde.

830: Italy, 17th century.
831: Motif from tomb. China, 7th century.
832: Directoire frieze motif. France.
833: Second Empire motif. France.
834: Dish. China, 4th-3rd centuries BC.
835: Ming period motif, China, 16th century.
836: China, 3rd century BC.
837: Brocade motif. Benares, India.
838: Block for textile printing. Lucknow, India, 20th century.
839: Block for textile printing. India.
840: Jewel. India, 19th century.

830: XVII. Jahrh., Italien.
831: Grabmal, VII. Jahrh., China.
832: Fries, Directoire, Frankreich.
833: Zweites Kaiserreich, Frankreich.
834: Schale, IV. - III. Jahrh. v. Chr., China.
835: Ming-Zeit, XVI. Jahrh., China.
836: III. Jahrh. v. Chr., China.
837: Brokat, Benarès, Indien.
838: Holzstock zum Bedrucken von Stoffen, XX. Jahrh., Lucknow, Indien.
839: Holzstock zum Bedrucken von Stoffen, Indien.
840: Schmuckstück, XIX. Jahrh., Indien.

830

831

832

833

834

835

836

837

838

839

840

841

841

841: Tissu, XVIᵐᵉ siècle, Italie.
842: Motif ornemental, art roman.

841: Textile motif. Italy, 16th century.
842: Romanesque motif.

841: Gewebe, XVI. Jahrh., Italien.
842: Romanisch.

842

842

843: Motif ornemental, Inde.
844: Gant brodé, Indiens Sioux, Amérique du Nord.
845: Mocassin brodé, Indiens Hurons, Canada.
846: Motif ornemental inspiré par le style Renaissance, Second Empire, France.
847: Motif ornemental, art gothique, cathédrale de Wells, Angleterre.
848: Frise, Directoire, France.
849: Motif ornemental inspiré par le style Louis XIII, Second Empire, France.

843: India.
844: Sioux Indian embroidered glove. North America.
845: Huron Indian embroidered moccasin. Canada.
846: Second Empire motif in Renaissance style. France.
847: Gothic motif. Wells Cathedral, England.
848: Directoire frieze motif. France.
849: Second Empire motif in Louis XIII style. France.

843: Indien.
844: Bestickter Handschuh, Sioux-Indianer Nordamerika.
845: Bestickter Mokassin, Huron-Indianer, Kanada.
846: Renaissance beeinflusstes Ornament-Motiv, Zweites Kaiserreich, Frankreich.
847: Gotisch, Kathedrale von Wells, England.
848: Fries, Directoire, Frankreich.
849: Vom Louis-treize-Stil beeinflusstes Ornament-Motiv, Zweites Kaiserreich, Frankreich.

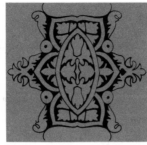

843

844

845

846

847

848

849

850

851

852

853

854: Motif ornemental, VIIIᵐᵉ-IXᵐᵉ siècle, Mayas, Yucatan, Mexique.
855: Motif ornemental inspiré du style grec, Second Empire, France.
856: Motif ornemental inspiré du style grec, Second Empire, France.
857: Couronnes de laurier, Empire, France.
858: Couronne, Iᵉʳ siècle av. J.-C., Tyr, Syrie.
859: Vignette, Empire, France.
860: Motif ornemental inspiré du style grec, Second Empire, France.
861: Corne d'abondance, Directoire, France.

854: Maya motif. Yucatán, Mexico, 8th-9th centuries.
855: Second Empire Grecian motif. France.
856: Second Empire Grecian motif. France.
857: Empire laurel-wreath motif. France.
858: Wreath motif. Tyre, Syria, 1st century BC.
859: Empire printer's ornament. France.
860: Second Empire Grecian motif. France.
861: Directoire cornucopia motif. France.

854: VIII. - IX. Jahrh., Maya, Yukatan.
855: Griechisch beeinflusstes Ornament-Motiv, Zweites Kaiserreich, Frankreich.
856: Griechisch beeinflusstes Ornament-Motiv, Zweites Kaiserreich, Frankreich.
857: Lorbeerkranz, Empire, Frankreich.
858: Kranz, I. Jahrh. v. Chr., Tyrus, Syrien.
859: Vignette, Empire, Frankreich.
860: Griechisch beeinflusstes Ornament-Motiv, Zweites Kaiserreich, Frankreich.
861: Füllhörner, Directoire, Frankreich.

854

855

856

857

858

859

860

861

862: Encadrement, Directoire, France.

862: Directoire ornamental border. France.

862: Einrahmung, Directoire, Frankreich.

863: Rinceau (vigne), Ier-IIme siècle, Palmyre, Syrie.
864: En-tête de page, Renaissance, France.
865: Bordure de tissu, art copte, Egypte.
866: Frise, Chine.

863: Vine-leaf scroll motif. Palmyra, Syria, 1st-2nd centuries.
864: Renaissance period printer's headpiece. France.
865: Coptic textile border motif. Egypt.
866: Frieze motif. China.

863: Weinranke, I. - II. Jahrh., Palmyre, Syrien.
864: Kopf einer Seite, Renaissance, Frankreich.
865: Stoffbordüre, koptisch, Ägypten.
866: Fries, China.

863

863

864

865

866

867

867

868

869

870

871: Frise, Turkestan chinois.
872: Motif ornemental, Empire, France.
873: Frise, Empire, France.
874: Motif ornemental, XVIᵐᵉ siècle, Espagne.

871: Frieze motif. Chinese Turkestan.
872: Empire motif. France.
873: Empire frieze motif. France.
874: Spain, 16th century.

871: Fries, Chinesisch-Turkestan.
872: Empire, Frankreich.
873: Fries, Empire, Frankreich.
874: XVI. Jahrh., Spanien.

871

872

873

874

875

876

877

878

878

**Motifs ornementaux
issus d'animaux**

**Ornaments based on animal
forms**

**Ornament-Motive aus der
Tierwelt**

879

880

881

882

883

883

884: Dragons, Turquie.
885: Tissu, époque précolombienne, Incas, Pérou.
886: Motif ornemental, époque précolombienne, Incas, Pérou.
887: Motif ornemental, époque précolombienne, Incas, Pérou.

884: Dragon motif. Turkey.
885: Inca textile motif. Precolumbian Peru.
886: Inca motif. Precolumbian Peru.
887: Inca motif. Precolumbian Peru.

884: Drachen, Türkei.
885: Gewebe, prä-kolumbianisch, Inka, Peru.
886: Prä-kolumbianisch, Inka, Peru.
887: Prä-kolumbianisch, Inka, Peru.

884

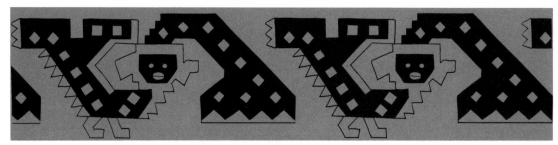
885

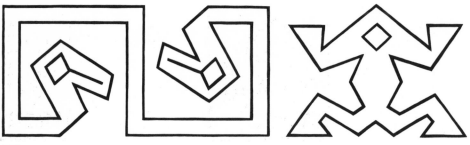
886

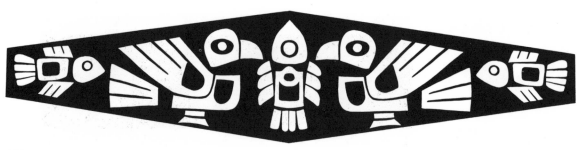
887

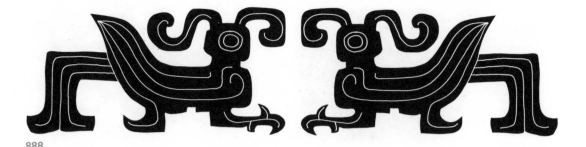

888

889

890

891

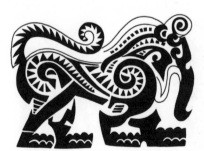

892

893

888: Oiseau stylisé, XIme-VIIIme siècle av. J.-C.,
Chine.
889: Vase Ting, époque Chang, XIIIme-XIme
siècle av. J.-C., Chine.
890: Motif ornemental, XIme siècle av. J.-C.,
Chine.
891: Tombeau Han, IIme siècle av. J.-C., Chine.
892: Eléphant stylisé, époque des Six Dynasties,
Xme siècle, Chine.
893: Motif ornemental, époque Tcheou, XIIme-
IIIme siècle av. J.-C., Chine.

888: Stylized bird motif. China, 11th-8th cen-
turies BC.
889: Ting vase of Chang period. China, 13th-
11th centuries BC.
890: China, 11th century BC.
891: Motif from Han tomb. China, 2nd century
BC.
892: Stylized elephant motif of Six Dynasties
period. China, 10th century.
893: Chow period motif. China, 12th-3rd cen-
turies BC.

888: Stilisierter Vogel, XI. - VIII. Jahrh. v. Chr.,
China.
889: Ting-Vase, Chang, XIII. - XI. Jahrh. v. Chr.,
China.
890: XI. Jahrh. v. Chr., China.
891: Han-Grabmal, II. Jahrh. v. Chr., China.
892: Stilisierter Elefant, Epoche der Sechs Dynas-
tien, X. Jahrh., China.
893: Tschou-Zeit, X. - III. Jahrh. v. Chr., China.

894: Tête stylisée, tapis, IVᵐᵉ-IIIᵐᵉ siècle av.
J.-C., Pazyryk, Sibérie.
895: Dragons, époque prébouddhiste, Japon.
896: Coq stylisé, IVᵐᵉ-IIIᵐᵉ siècle av. J.-C.,
Pazyryk, Sibérie.
897: Coq stylisé, Sibérie.
898: Coq stylisé, Sibérie.
899: Coqs stylisés, IVᵐᵉ-IIIᵐᵉ siècle av. J.-C.,
Pazyryk, Sibérie.
900: Animal stylisé, Côte-d'Ivoire.
901: Filigrane de papier, XVᵐᵉ siècle, France.
902: Oiseau stylisé, île de Pâques, Chili.
903: Oiseau stylisé, île de Pâques, Chili.

894: Stylized head, carpet motif. Pazyryk, Siberia, 4th-3rd centuries BC.
895: Pre-Buddhist dragon motif. Japan.
896: Stylized cock motif. Pazyryk, Siberia, 4th-3rd centuries BC.
897: Stylized cock motif. Siberia.
898: Stylized cock motif. Siberia.
899: Stylized cock motif. Pazyryk, Siberia, 4th-3rd centuries BC.
900: Stylized animal motif. Ivory Coast.
901: Paper watermark. France, 15th century.
902: Stylized bird motif. Easter Island.
903: Stylized bird motif. Easter Island.

894: Teppich, IV. - III. Jahrh. v. Chr., Pazyryk,
Sibirien.
895: Drachen, prä-buddhistisch, Japan.
896: Stilisierter Hahn, IV. - III. Jahrh. v. Chr.,
Pazyryk, Sibirien.
897: Stilisierter Hahn, Sibirien.
898: Stilisierter Hahn, Sibirien.
899: Stilisierte Hähne, IV - III. Jahrh. v. Chr.,
Pazyryk, Sibirien.
900: Stilisiertes Tier, Elfenbeinküste.
901: Papierfiligran, XV. Jahrh., Frankreich.
902: Stilisierter Vogel, Osterinsel, Chile.
903: Stilisierter Vogel, Osterinsel, Chile.

894

895

896

897

898

899

900

901

902

903

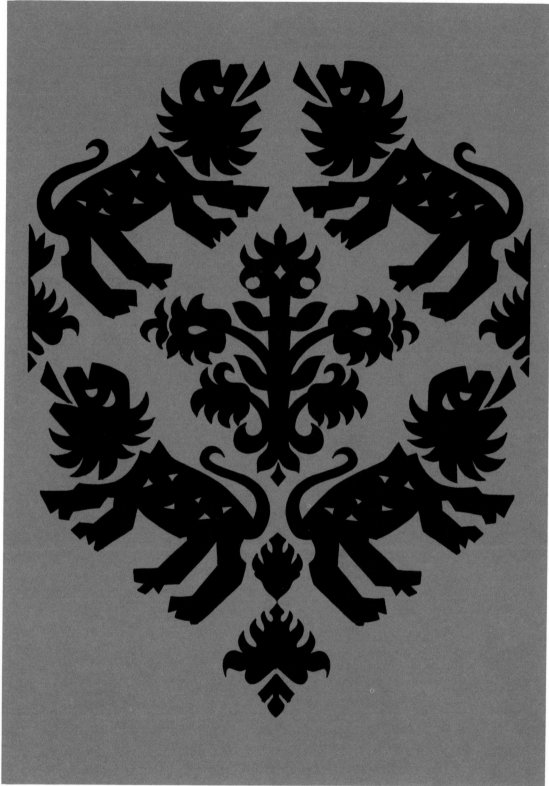

904

904: Brocatelle, art hispano-sicilien, XV^me siècle.

904: *Hispano-Sicilian brocade motif. Sicily, 15th century.*

904: Brokatimitation, spanisch-sizilianisch, XV. Jahrh.

904 213

905 : Motif ornemental, époque précolombienne, Pérou.
906 : Motif ornemental, art hispano-mauresque, XV^{me} siècle, Espagne.
907 : Tissu, art musulman.
908 : Motif ornemental, V^{me}-III^{me} siècle av. J.-C., Chine.
909 : Serpent, art roman, France.
910 : Motif ornemental, V^{me}-III^{me} siècle av. J.-C., Chine.
911 : Motif ornemental, XVIII^{me} siècle, Suède.
912 : Motif ornemental, époque Han, II^{me} siècle av. J.-C., Chine.
913 : Poulpe, époque mycénienne, Tirynthe, Grèce.

905: Precolumbian Peru.
906: Morisco motif. Valencia, Spain, 15th century.
907: Islamic textile motif.
908: China, 5th-3rd centuries BC.
909: Romanesque snake motif. France.
910: China, 5th-3rd centuries BC.
911: Sweden, 18th century.
912: Han period motif. China, 2nd century BC.
913: Mycenean octopus motif. Tiryns, Greece.

905 : Prä-kolumbianisch, Peru.
906 : Muselmanisch, XV. Jahrh., Spanien.
907 : Gewebe, muselmanisch.
908 : V. - III. Jahrh. v. Chr., China.
909 : Schlange, romanisch, Frankreich.
910 : V. - III. Jahrh. v. Chr., China.
911 : XVIII. Jahrh., Schweden.
912 : Han-Zeit, II. Jahrh. v. Chr., China.
913 : Tintenfisch, mykenisch, Tiryns, Griechenland.

905

906

907

908

909

910

911

912

913

914

914

915

916

917

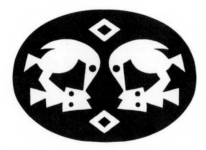

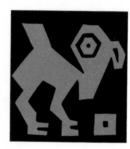

918

919

920

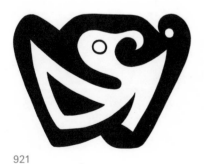

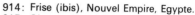

921

922

923

924: Dragon, époque Han, Chine.
925: Serre d'oiseau, IXme-XIIIme siècle, Ohio, U.S.A.
926: Dragon, époque Han, Chine.
927: Dragon, époque Tcheou, XIIme-IIIme siècle av. J.-C., Chine.
928: Nuages en forme de dragons, tissu, Turquie.
929: Crabe, Indiens, Alaska, U.S.A.
930: Broderie, IIme siècle av. J.-C., Chine.

924: *Han period dragon motif. China.*
925: *Bird-claw motif. Ohio, U.S.A., 9th-13th centuries.*
926: *Han period dragon motif. China.*
927: *Chow period dragon motif. China, 12th-3rd centuries BC.*
928: *Dragon-shaped cloud motif. Turkey.*
929: *Indian crab motif. Alaska, U.S.A.*
930: *Embroidery motif. China, 2nd century BC.*

924: Drache, Han-Zeit, China.
925: Vogelkralle, IX. - XIII. Jahrh., Ohio, USA.
926: Drache, Han-Zeit, China.
927: Drache, Tschou, X. - III. Jahrh. v. Chr., China.
928: Wolken in Drachenform, Gewebe, Türkei.
929: Krabbe, Indianisch, Alaska, USA.
930: Stickerei, II. Jahrh. v. Chr., China.

924

925

926

927

928

929

930

931

931: Aigle, Indiens Haïdas, côte nord-ouest, Amérique du Nord.

931: Haida Indian eagle motif. North-West Coast, North America.

931: Adler, Haida-Indianer, Nordwestküste von Nordamerika.

932

932: Plaque pectorale (or et pierres précieuses),
 12me dynastie, Egypte.
933: Ailes déployées, VIIIme siècle av. J.-C.,
 Hittites, Asie Mineure.
934: Motif ornemental, XVIIIme siècle, Alle-
 magne.
935: Motif ornemental, VIIIme-Xme siècle, Mayas,
 Yucatan, Mexique.
936: Poulpe, céramique, Mycènes, Grèce.
937: Motif ornemental, XIXme siècle, U.R.S.S.
938: Tissu, XIVme siècle, Venise, Italie.
939: Tissu, XXme siècle, Finlande.
940: Motif ornemental, Océanie.

*932: XIIth Dynasty gold and jewelled pectoral
 ornament. Egypt.*
*933: Hittite extended wing motif. Asia Minor,
 8th century BC.*
934: Germany, 18th century.
*935: Maya motif. Yucatán, Mexico, 8th-10th
 centuries.*
936: Ceramic octopus motif. Mycenae, Greece.
937: U.S.S.R., 19th century.
938: Textile motif. Venice, Italy, 14th century.
939: Textile motif. Finland, 20th century.
940: South Pacific.

932: Brustschild (Gold und Edelsteine), 12.
 Dynastie, Ägypten.
933: Ausgebreitete Flügel, VIII. Jahrh. v. Chr.,
 Hethiter, Kleinasien.
934: XVIII. Jahrh., Deutschland.
935: VIII. - X. Jahrh., Maya, Yukatan.
936: Tintenfisch, Keramik, Mykene, Griechen-
 land.
937: XIX. Jahrh., UdSSR.
938: Gewebe, XIV. Jahrh., Venedig, Italien.
939: Gewebe, XX. Jahrh., Finnland.
940: Ozeanien.

933

934

935

936

937

938

939

940

941

942

943

944

945

946

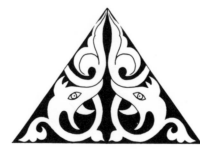

947

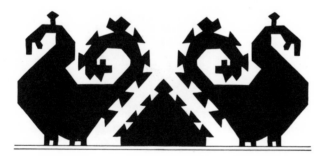

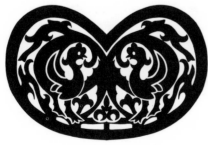

948

949

950

951

952 : Arrière de pirogue, Indiens Kwakiutls, côte nord-ouest, Amérique du Nord.
953 : L'Oiseau Tonnerre, Indiens Tlingits, côte nord-ouest, Amérique du Nord.
954 : Motif ornemental, île Haï-nan, golfe du Tonkin.
955 : Motif ornemental, époque précolombienne, Pérou.
956 : Motif ornemental, époque précolombienne, Pérou.
957 : Motif ornemental, Teotihuacan, Mexique.
958 : Motif ornemental, époque précolombienne, Incas, Pérou.
959 : Motif ornemental, époque précolombienne, Incas, Pérou.
960 : Motif ornemental, époque précolombienne, Pérou.
961 : Céramique, Mesa Verde, Colorado, U.S.A.

952 : *Kwakiutl Indian canoe stern motif. North-West Coast, North America.*
953 : *Tlingit Indian Thunderbird motif. North-West Coast, North America.*
954 : *Hainan Island, Gulf of Tonkin.*
955 : *Precolumbian Peru.*
956 : *Precolumbian Peru.*
957 : *Teotihuacán, Precolumbian Mexico.*
958 : *Inca motif. Precolumbian Peru.*
959 : *Inca motif. Precolumbian Peru.*
960 : *Precolumbian Peru.*
961 : *Indian ceramic motif. Mesa Verde, Colorado, U.S.A.*

952 : Rückseite eines Einbaums, Kwakiutl-Indianer, Nordwestküste von Nordamerika.
953 : Donnervogel, Tlingit-Indianer, Nordwestküste von Nordamerika.
954 : Insel Hainan, Golf von Tonking.
955 : Prä-kolumbianisch, Peru.
956 : Prä-kolumbianisch, Peru.
957 : Teotihuacán, Mexiko.
958 : Prä-kolumbianisch, Inka, Peru.
959 : Prä-kolumbianisch, Inka, Peru.
960 : Prä-kolumbianisch, Peru.
961 : Keramik, Mesa Verde, Colorado, USA.

952

953

954

955

956

957

958

959

960 961

962

962: Motif ornemental, époque précolombienne, Incas, Pérou.

962: Inca motif. Precolumbian Peru.

962: Prä-kolumbianisch, Inka, Peru.

963 : Bois peint, Cameroun.
964 : Bois peint, Cameroun.
965 : Bois peint, Cameroun.
966 : Motif ornemental, archipel malais.
967 : Motif ornemental, Indiens Salishs, côte
nord-ouest, Amérique du Nord.
968 : Motif ornemental, époque précolombienne,
Pérou.
969 : Motif ornemental, art musulman, XIV^me
siècle, Espagne.
970 : Motif ornemental, époque précolombienne,
Pérou.
971 : Motif ornemental, époque précolombienne,
Pérou.

963 : *Painted wood motif. Cameroon.*
964 : *Painted wood motif. Cameroon.*
965 : *Painted wood motif. Cameroon.*
966 : *Malay Archipelago.*
967 : *Salish Indian motif. North-West Coast,
North America.*
968 : *Precolumbian Peru.*
969 : *Islamic motif. Spain, 14th century.*
970 : *Precolumbian Peru.*
971 : *Precolumbian Peru.*

963 : Holzbemalung, Kamerun.
964 : Holzbemalung, Kamerun.
965 : Holzbemalung, Kamerun.
966 : Malaischer Archipel.
967 : Salish-Indianer, Nordwestküste von Nord-
amerika.
968 : Prä-kolumbianisch, Peru.
969 : Muselmanisch, XIV. Jahrh., Spanien.
970 : Prä-kolumbianisch, Peru.
971 : Prä-kolumbianisch, Peru.

963

964

965

966

967

968

969

970

971

972

972: Vignette typographique (Deberny et Peignot), début du XXᵐᵉ siècle, Paris, France.
973: Motif ornemental, Indiens Iowas, Oklahoma, U.S.A.
974: Motif ornemental, époque préhistorique, Indiens Pueblos, Nouveau-Mexique, U.S.A.

972: *Type ornament, cast by Deberny and Peignot. Paris, France, beginning of 20th century.*
973: *Iowa Indian motif. Oklahoma, U.S.A.*
974: *Prehistoric Pueblo motif. New Mexico, U.S.A.*

972: Typographische Vignette (Deberny und Peignot), Anfang des XX. Jahrh., Paris, Frankreich.
973: Iowa-Indianer, Oklahoma, USA.
974: Prähistorisch, Pueblos, Neu-Mexiko, USA.

973

974

974

975 : Bois gravé pour imprimer les tissus, XXᵐᵉ
siècle, Lucknow, Inde.
976 : Motif ornemental, XXᵐᵉ siècle, U.R.S.S.
977 : Tapis, Yaling, Chensi, Chine.
978 : Motif ornemental, Indiens Salishs, côte
nord-ouest, Amérique du Nord.
979 : Tapis, Yaling, Chensi, Chine.
980 : Oiseaux face à face, art roman.
981 : Tapis, XVIIᵐᵉ siècle, Inde.
982 : Tissu imprimé, Hounan, Chine.

*975 : Wood block for textile printing. Lucknow,
India, 20th century.*
976 : U.S.S.R., 20th century.
977 : Carpet motif. Yaling, Chensi, China.
*978 : Salish Indian motif. North-West Coast,
North America.*
979 : Carpet motif. Yaling, Chensi, China.
980 : Romanesque face-to-face bird motif.
981 : Carpet motif. India, 17th century.
982 : Textile motif. Hunan, China.

975 : Holzstock zum Bedrucken von Stoffen,
XX. Jahrh., Lucknow, Indien.
976 : XX. Jahrh., UdSSR.
977 : Teppich, Yaling, Schensi, China.
978 : Salish-Indianer, Nordwestküste von Nord-
amerika.
979 : Teppich, Yaling, Schensi, China.
980 : Gegenübergestellte Vögel, romanisch.
981 : Teppich, XVII. Jahrh., Indien.
982 : Stoffdruck, Honan, China.

975

976

977

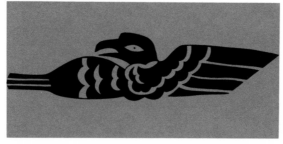

978

979

980

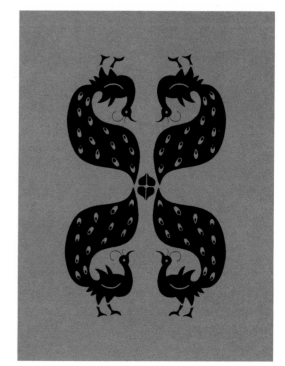

981

982

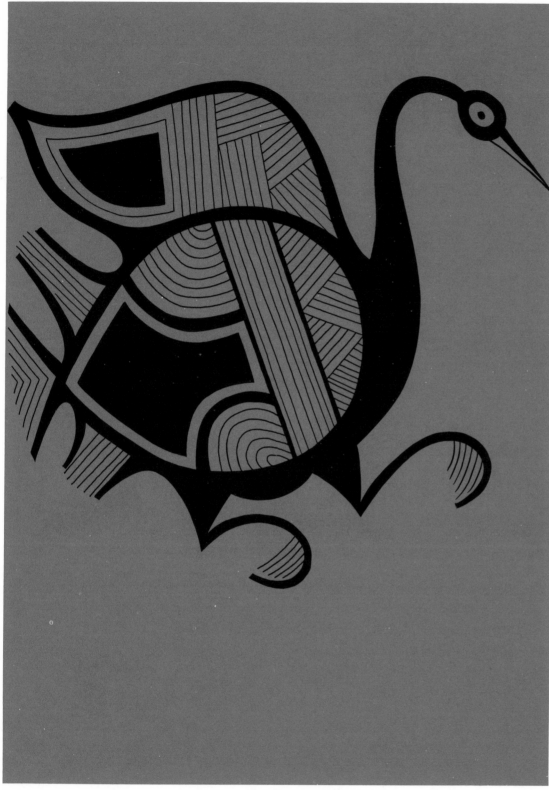

983: Motif ornemental, céramique, âge du fer, Chypre.

983: Iron Age ceramic motif. Cyprus.

983: Keramik, Eisenzeit, Zypern.

983

984: Motif ornemental, époque précolombienne, Pérou.
985: Motif ornemental, Océanie.
986: Motif ornemental, Indiens Iroquois, Amérique du Nord.
987: Motif ornemental, Indiens Hohokams, Arizona, U.S.A.
988: Motif ornemental, Mali.
989: Motif ornemental, art musulman, XVme siècle, Andalousie, Espagne.
990: Monnaie, Grèce.
991: Filigrane de papetier, XVme siècle, France.
992: Filigrane de papetier, XVme siècle, France.
993: Dragon, XIIme siècle av. J.-C., Chine.
994: Motif ornemental, époque précolombienne, Incas, Pérou.
995: Motif ornemental, archipel malais.

984: Precolumbian Peru.
985: South Pacific.
986: Iroquois Indian motif. North America.
987: Hohokam Indian motif. Arizona, U.S.A.
988: Mali.
989: Islamic motif. Andalucia, Spain, 15th century.
990: Coin, Ancient Greece.
991: Paper watermark. France, 15th century.
992: Paper watermark. France, 15th century.
993: Dragon motif. China, 12th century BC.
994: Inca motif. Precolumbian Peru.
995: Malay Archipelago.

984: Prä-kolumbianisch, Peru.
985: Ozeanien.
986: Irokesen-Indianer, Nordamerika.
987: Hohokam-Indianer, Arizona, USA.
988: Mali.
989: Muselmanisch, XV. Jahrh., Andalusien, Spanien.
990: Geld, Griechenland.
991: Papierfiligran, XV. Jahrh., Frankreich.
992: Papierfiligran, XV. Jahrh., Frankreich.
993: Drache, XII. Jahrh. v. Chr., China.
994: Prä-kolumbianisch, Inka, Peru.
995: Ornament-Motiv, Malaischer Archipel.

984

985

986

987

988

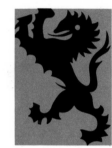
989

990

991

992

993

994

995

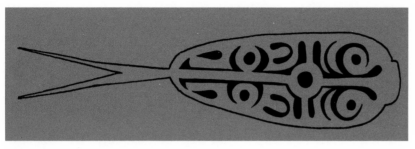

996

997

997

998

999

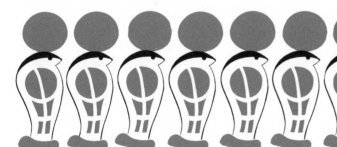

1000

996 : Tête de serpent, Indiens Hopewells, Ohio,
U.S.A.
997 : Nuage stylisé, Chine.
998 : Mosaïque, Aztèques, Mexique.
999 : Motif ornemental, Suse, Iran.
1000 : Motif ornemental, Nouvel Empire, Egypte.

*996 : Hopewell Indian snake-head motif. Ohio,
U.S.A.*
997 : Stylized cloud motif. China.
*998 : Aztec double-headed serpent mosaic motif.
Precolumbian Mexico.*
999 : Susa, Persia.
1000 : New Empire period motif. Egypt.

996 : Schlangenkopf, Hopewell-Indianer, Ohio,
USA.
997 : Stilisierte Wolke, China.
998 : Mosaik, Azteken, Mexiko.
999 : Susa, Iran.
1000 : Neues Reich, Ägypten.

Index

Index

Index

Les chiffres mentionnés dans l'Index correspondent à la numérotation des illustrations. Les numéros des motifs contenus dans une page sont indiqués EN COULEUR au bas de chacune d'elles. Le nom des pays est généralement exprimé par leur appellation actuelle.

The numbers given in the Index are those of the illustrations. The numbers of the illustrations appearing on each page of the book are listed IN COLOUR at the foot of the page concerned. The names of countries are given in the form used today.

Die im Index angeführten Ziffern entsprechen den Nummern der Abbildungen. Die Zahlenangaben für alle Motive auf jeweils einer Seite sind IN FARBE am Fuss jeder Seite verzeichnet. Die Benennung der einzelnen Länder entspricht der im Augenblick gültigen Form.